photographing

Boston

Where to Find Perfect Shots and How to Take Them

Steven Howell

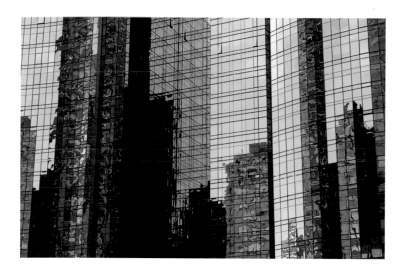

The Countryman Press
Woodstock, Vermont

Maps by Paul Woodward, © The Countryman Press
Photographs on pages 38, 69 and 91 © Kim Grant

Photographing Boston
978-0-88150-916-8

Published by The Countryman Press,
P.O. Box 748, Woodstock, VT 05091

Distributed by W. W. Norton & Company, Inc.,
500 Fifth Avenue, New York, NY 10110

Printed in the United States by Versa Press, East Peoria, IL

10 9 8 7 6 5 4 3 2 1

Title Page: InterContinental Hotel
Right: Back Bay architecture

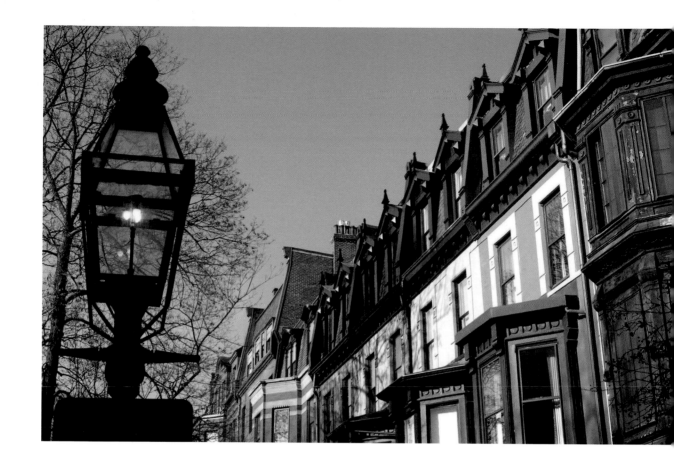

Acknowledgments

Very special thanks go to:

Char and Dar: Charlene Earle and Darcy Gilbo—my Salem hostesses with the mostesses. You are my two favorite beans in all of Boston!

Rick Hayes and Sarah White—my extraordinary Saint Paddy's Day Boston road trip pals.

Neal Citro, Lévi Bérubé, and Roland Laliberté—who always provide me with an encouraging word.

My friends and colleagues at The Countryman Press, including Lisa Sacks, Kermit Hummel, and Iris Bass for her copyediting prowess.

Gil Duken—the biggest Boston Red Sox fan I know!

Rosanne Mercer for her help with Skywalk Observatory andElisa Vaudo for the inside scoop on the BDC.

The fine folks of the City of Boston.

A very special thanks to Kim Grant—great photos!

And to Derek Isaac—I look forward to our next photo shoot together.

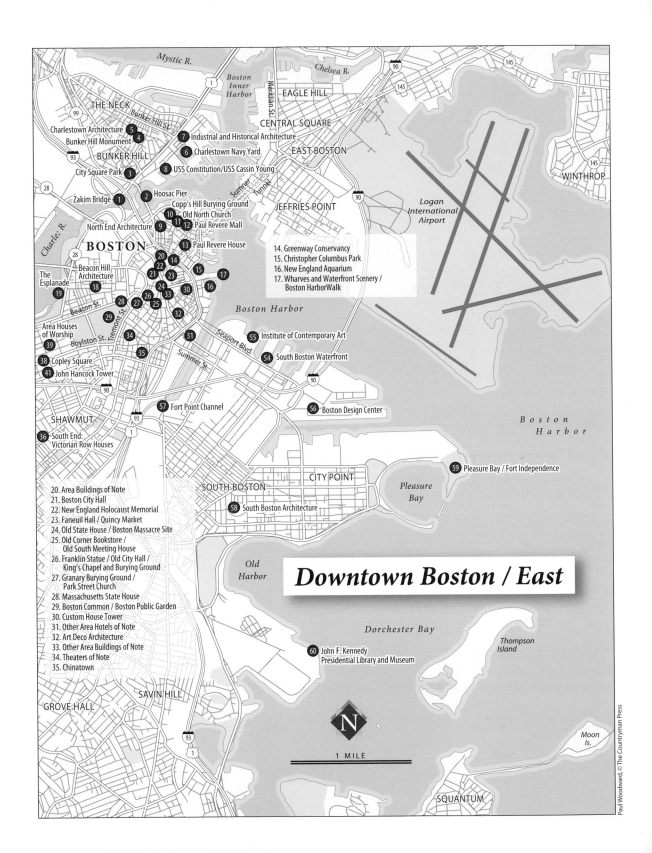

Mystic R.

Chelsea R.

Boston Inner Harbor

EAGLE HILL

THE NECK

CENTRAL SQUARE

Charlestown Architecture **5**
Bunker Hill Monument **4**
7 Industrial and Historical Architecture

EAST BOSTON

6 Charlestown Navy Yard

BUNKER HILL

City Square Park **3**
8 USS Constitution/USS Cassin Young

Zakim Bridge **1**
2 Hoosac Pier

JEFFRIES POINT

Copp's Hill Burying Ground
Old North Church
10
North End Architecture **9** **11**
12 Paul Revere Mall

Logan International Airport

BOSTON

13 Paul Revere House

WINTHROP

14. Greenway Conservancy
15. Christopher Columbus Park
16. New England Aquarium
17. Wharves and Waterfront Scenery /
 Boston HarborWalk

Beacon Hill Architecture
20 14
22 19 15
21 23 17
The Esplanade **18** **24 16**
19 **26 30**
Area Houses **28 27 25 33**
of Worship **29 32**
39 **34**
Boylston St. **31**
35 Summer St.

Boston Harbor

55 Institute of Contemporary Art
54 South Boston Waterfront

38 Copley Square
41 John Hancock Tower

57 Fort Point Channel

SHAWMUT

56 Boston Design Center

Boston Harbor

36 South End:
Victorian Row Houses

20. Area Buildings of Note
21. Boston City Hall
22. New England Holocaust Memorial
23. Faneuil Hall / Quincy Market
24. Old State House / Boston Massacre Site
25. Old Corner Bookstore /
 Old South Meeting House
26. Franklin Statue / Old City Hall /
 King's Chapel and Burying Ground
27. Granary Burying Ground /
 Park Street Church
28. Massachusetts State House
29. Boston Common / Boston Public Garden
30. Custom House Tower
31. Other Area Hotels of Note
32. Art Deco Architecture
33. Other Area Buildings of Note
34. Theaters of Note
35. Chinatown

59 Pleasure Bay / Fort Independence

CITY POINT

Pleasure Bay

SOUTH BOSTON

58 South Boston Architecture

Old Harbor

Downtown Boston / East

Dorchester Bay

Thompson Island

60 John F. Kennedy
Presidential Library and Museum

GROVE HALL

SAVIN HILL

Moon Is.

N

1 MILE

SQUANTUM

Paul Woodward, © The Countryman Press

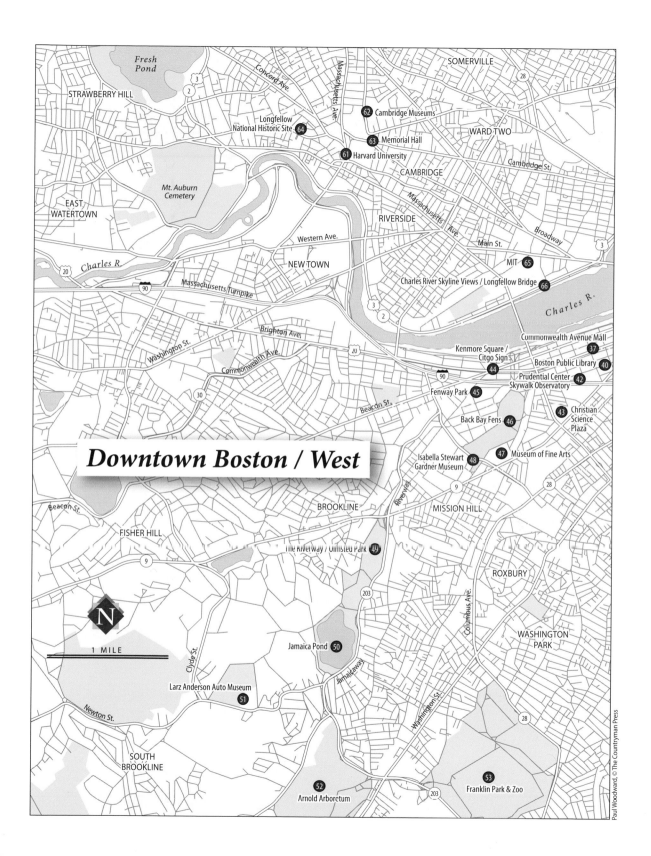

Fresh Pond

STRAWBERRY HILL

Concord Ave.

Massachusetts Ave.

SOMERVILLE

28

62 Cambridge Museums

WARD TWO

Longfellow National Historic Site 64

63 Memorial Hall

61 Harvard University

CAMBRIDGE

Cambridge St.

Mt. Auburn Cemetery

EAST WATERTOWN

RIVERSIDE

Massachusetts Ave.

Broadway

Western Ave.

Main St.

20

Charles R.

NEW TOWN

MIT 65

90

Massachusetts Turnpike

Charles River Skyline Views / Longfellow Bridge 66

Charles R.

Brighton Ave.

Commonwealth Avenue Mall

Washington St.

20

Kenmore Square / Citgo Sign

37

Commonwealth Ave.

90

44

Boston Public Library 40

Prudential Center Skywalk Observatory 42

30

Fenway Park 45

43 Christian Science Plaza

Beacon St.

Back Bay Fens 46

47 Museum of Fine Arts

Downtown Boston / West

Isabella Stewart Gardner Museum 48

28

9

Beacon St.

BROOKLINE

Riverway

MISSION HILL

FISHER HILL

The Riverway / Olmsted Park 49

9

ROXBURY

203

N

Columbus Ave.

WASHINGTON PARK

1 MILE

Jamaica Pond 50

Clyde St.

Jamaicaway

Larz Anderson Auto Museum 51

Washington St.

Newton St.

28

SOUTH BROOKLINE

52

203

53 Franklin Park & Zoo

Arnold Arboretum

Paul Woodward, © The Countryman Press

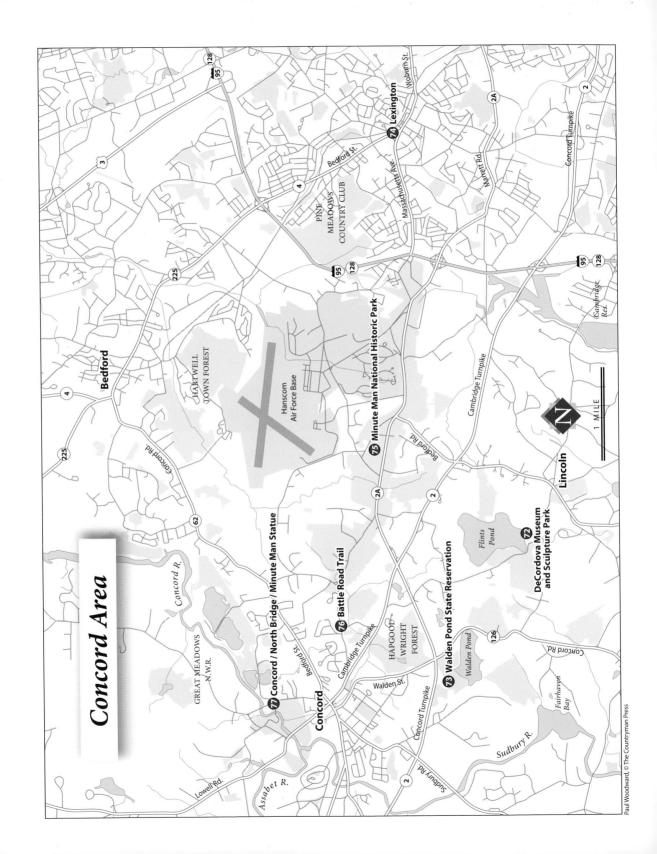

Concord Area

Paul Woodward, © The Countryman Press

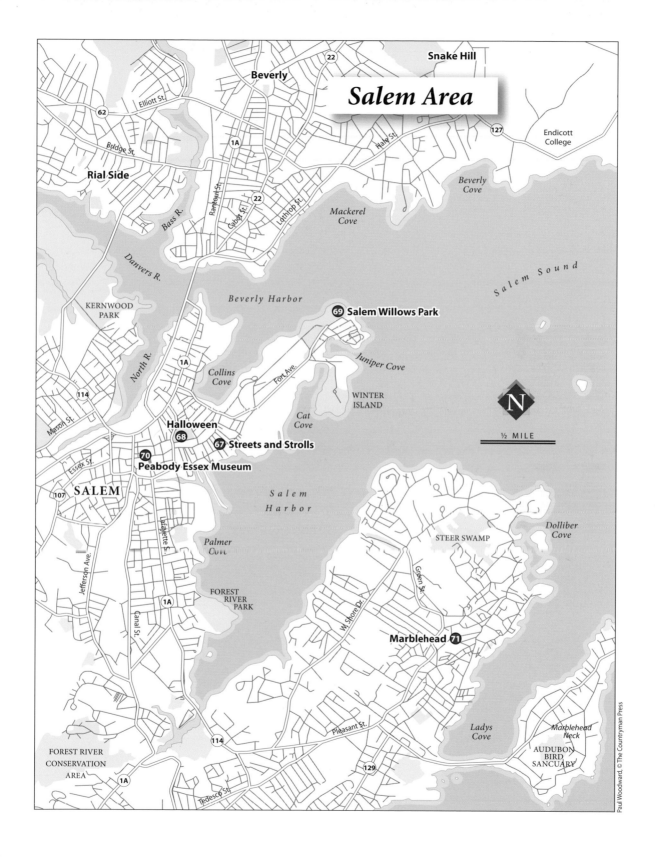

Salem Area

Snake Hill

Beverly

Rial Side

Elliott St.

Bridge St.

Bass R.

Danvers R.

Rantoul St.

Cabot St.

Lothrop St.

Hale St.

Endicott College

Beverly Cove

Mackerel Cove

Salem Sound

Beverly Harbor

KERNWOOD PARK

69 Salem Willows Park

Juniper Cove

Collins Cove

Fort Ave.

WINTER ISLAND

N

½ MILE

North R.

Halloween

68

Cat Cove

67 Streets and Strolls

70

Essex St.

Peabody Essex Museum

SALEM

107

Salem Harbor

Mason St.

114

Jefferson Ave.

Lafayette S.

Palmer Cove

STEER SWAMP

Dolliber Cove

FOREST RIVER PARK

Green St.

W. Shore Dr.

Marblehead 71

Canal St.

1A

FOREST RIVER CONSERVATION AREA

1A

114

Pleasant St.

129

Ladys Cove

Marblehead Neck

AUDUBON BIRD SANCTUARY

Tedesco St.

Paul Woodward, © The Countryman Press

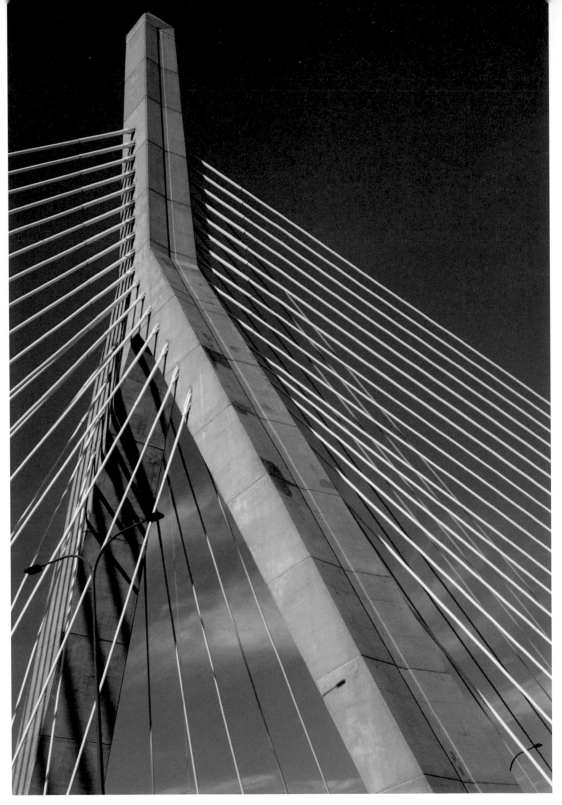

The Zakim Bridge

Contents

VII. South Boston/Convention District/South Boston Waterfront

VIII. Cambridge

IX. Points North

Salem area

Lexington/Lincoln/Concord

Concord Monument poem

BY THE RUDE BRIDGE THAT
ARCHED THE FLOOD,
THEIR FLAG TO APRIL'S
BREEZE UNFURLED,
HERE ONCE THE EMBATTLED
FARMERS STOOD,
AND FIRED THE SHOT HEARD
ROUND THE WORLD.

Introduction

Although trained as a writer first, photography has personally allowed me to explore the visual, artistic side of my brain. In the recent past, I have been blessed to photograph and write about Montreal, Quebec City, New York City, and now Boston—and what a fun photo op Boston is.

I am a native Long Islander who now lives upstate New York, but Boston has always held a special place in my heart. I first fell in love with the city on a high school field trip in the early 1980s—I even have some vintage photos of Boston Common Swan Boats and a Salem side trip to prove it. I returned to Boston dozens of times while working for a regional New England airline during the 1990s. And I travel frequently to the Boston metropolitan area—I have friends who live in Salem. I devoted a few weeks to working on this book in the beautiful city of Boston.

I tried to organize this book as conveniently and logically as possible, taking the photo ops one neighborhood at a time. Most of the iconic historical Boston sightseeing stops are mentioned, including Freedom Trail highlights, Emerald Necklace outdoor gems, and city neighborhoods and hubs, such as Charlestown, the North End, Beacon Hill, the Back Bay, the Fens, and South Boston. A few off-the-beaten-path road-trip subjects are mentioned as well.

This is not an all-inclusive book; rather, about 100 of Boston's best photo subjects that inspire me the most. It's impossible to mention all the photographic opportunities that Boston has to offer. You will no doubt discover a few of your own favorites along the way. To the tourist: Visit a part of town or neighborhood that wasn't on your original travel itinerary. To

Christian Science Plaza

the local: Venture to a nearby part of town that you haven't visited in a while.

To both the visitor and the resident: Be prepared to be photographically inspired by the beautiful city of Boston.

How to Use This Book

This book is geared toward photographers of all levels. Whether you're a point-and-shoot beginner, an avid amateur with your first digital SLR, or a serious pro who aims to add your own unique flair and perspective to a subject that's been photographed many times before—I've got some great suggestions for you all.

I've also listed some basic photo techniques. To the seasoned pro: While you may not learn anything new as far as technique is concerned, I try to include information such as lighting, best times of day to shoot, admission fees, commercial permit requirements, any applicable photo restrictions, and a bit of history about each subject. Each listing also includes addresses, Web sites, and telephone numbers.

This book is presented geographically by neighborhood. Most of the suggestions can be shot year-round. In fact, you'll find that as lighting and environment (e.g., haze, leaves, and snow) change with the season, so will your photographs. If you've the time or are a local, I suggest visiting these listings with each new season.

Spring is a great time to shoot. The temperature is often just right and I specifically enjoy photographing urban architecture when leaf buds are about to bloom on the local trees—you simply get to see more of a particular building and the trees don't look so bare. Summer offers lots to do and places to see, but sometimes washed-out and hazy skies. That said, the sunsets can prove dramatic and you can shoot well into the evening hours. The autumn landscape adds dramatic fall foliage, particularly along Boston's beautiful Emerald Necklace. With the arrival of winter, the best shots come with a fresh blanket of snow.

For the accompanying photos presented in this book, sometimes the camera settings will be included—but not always. Lighting conditions not only change from season to season but from second to second—think a partly sunny day when a cloud quickly moves in. I don't want you to duplicate all of my settings, but instead learn how to rely on your own here-and-now photographic instincts.

Tourist season runs throughout the year in Boston but peaks during summer. The point here: For some iconic Boston shots, such as the USS *Constitution* or Old North Church visits, be prepared to wait in line. A number of parades and festivals are included in case you're in town and want to shoot a specific event. I'm hoping you've already booked your hotel or are a local because you're on your own for accommodations. A few are mentioned in terms of geography within a particular neighborhood, not as a review for lodging. But I will mention a few restaurant suggestions—a photographer's got to eat, after all!

I walk and take public transportation whenever possible. Pertinent T stops are included with each listing. I also did a few neighborhood drives, particularly when visiting South Boston and many of the area's metropolitan green spaces. I'll let you know which destinations I reached by car and will include directions.

And what you see is what you get. I received no special entry to the places I visited, for example, private rooftop access. All of the vantage points within this book are open to the public with no special accommodations besides access fees (e.g., the Prudential Skywalk Observatory). The majority of the listings are city architecture, museums, seaside scenery, neighborhood strolls, most of the Freedom Trail highlights, and all of the Emerald Necklace. I

include museums for a number of reasons: I am a self-proclaimed museum junkie, the exterior façades are usually worth photographing, and there's something to see inside once you're there. That said, permission may be necessary for photos to be used commercially. Obtaining written permission from the respective public relations or communications department of your subject is highly recommended.

Uniquely Boston—Freedom Trail and Emerald Necklace

The Freedom Trail and Emerald Necklace are prominent subjects when photographing Boston—together they number more than a dozen entries in this book—and rightly so.

With the Freedom Trail, the city literally paints the town red—or at least its sidewalks. Boston began preserving its slice of colonial- and Revolutionary-era architecture during the late 1800s. Congress officially created Boston National Historical Park in 1974.

That said, the Freedom Trail was started a generation earlier in 1951 when locals sought to help visitors easily find their way about town to Boston's most prominent historical sites. Today, the Freedom Trail runs for 2.5 miles through a number of city neighborhoods to the heart of downtown. Some 1.5 million visitors walk the Freedom Trail annually, says the National Park Service. The Freedom Trail celebrates its 50th anniversary in 2011.

I love the Freedom Trail! It offers historical photo ops with every step; it gives a thorough overview of Boston's best attractions if time is limited; and, even though the streets wind this way and that, if you follow the red-painted bricks you simply cannot get lost!

The Emerald Necklace is another Boston original. Designed by acclaimed landscape architect Frederick Law Olmsted, the Emerald Necklace is a series of nine city green spaces

Art on the Greenway

that run from Boston Common to Franklin Park. Here, formal gardens, pedestrian bridges, grand tree-lined strolls, fountains, ponds, and rivers add to the photographic frame depending on which Emerald Necklace park you're in. Although the connected network of greenery spans for some 7 miles and is, in parts, most easily reached by car, you can access these urban oases by public transportation.

The Freedom Trail and Emerald Necklace entries are mostly not grouped individually but are listed geographically within each appropriate neighborhood chapter.

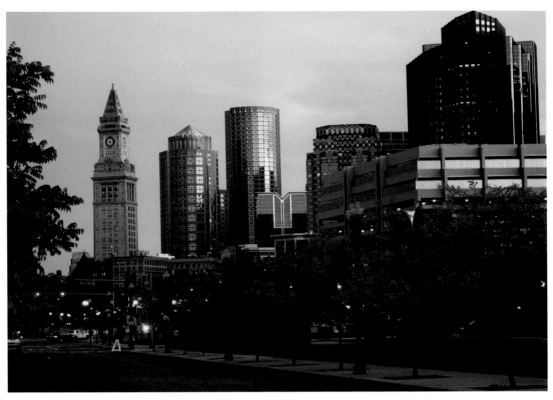

Skyline view from Causeway Street

How I Photograph Boston: Photographic Techniques

Buying a Digital Camera: Mega Pixels— Is Bigger Better?

In the market for a new camera? Taking better shots doesn't necessarily mean a bigger, better camera.

You don't have to buy the latest and greatest gear every time something new comes on the market—although the technology seems to improve monthly. Instead, consider the home of your photograph—this may help you decide what type of camera to buy.

Are you using your shots for a newspaper article, an art exhibition, or a stock photo agency? Each has different submission requirements. See what those photo editors require first. If you just want to share your photographs with family and friends, then use what you've got. If you currently use a point-and-shoot camera and are considering making the leap to a digital SLR—go for it. Quality camera equipment can be had for very reasonable prices. If looking to save money, last year's clearance models offer up-to-date technology at a less expensive price.

Welcome to the Digital Age

Congratulations on purchasing your new camera. Lesson number one: Read the instructions. You don't have to read that daunting 100-page instruction booklet all at once, but your digital camera can do some amazing things. Just take it one shot at a time.

Lesson number two: Get yourself good photo-processing software, such as Adobe Photoshop. Once again, it may be an intimidating tool at first, but learn one new technique at a time. Not only can your camera do some amazing things, the accompanying software can help clean up a variety of mistakes made in the field.

Equipment That Comes in Handy & Proper Camera Care

Get yourself a good camera bag, one made specifically for the purpose. That extra padding goes a long way in case of an accident.

You probably bought your camera in a kit complete with a lens. Lenses can be quite expensive—sometimes more expensive than the camera. Invest in a decent walk about lens, one that you won't have to change often that covers a variety of wide-angle and zoom shots. Check your local photo store for some good deals on used lenses as well.

I love my tripod but I don't use it all the time. But if I'm shooting a specific shot planned in advance, and especially at dawn, dusk, and night, I often bring my tripod. I sometimes use an automatic shutter release. The camera can still shake during long exposure night shots simply by your manually pressing the shutter—even when mounted to a tripod. Don't have a tripod handy when you need one? Use what you've got—a fence, a lamppost, your body—even a friend's head! Those mini bendable, flexible tripods work in a pinch and are easy to store or even keep attached to the camera base. If you have nothing

at hand, set your shooting mode to blast—one of those photos should come out clearer than the rest of the batch.

To clean the lens I almost always go dry, using a micro cloth made specifically for that purpose. Occasionally an alcohol-based cleaner will rid the lens of accumulated dirt or water spray spots. Don't use your clothes to clean your lens as there's probably sweat and dirt on that T-shirt, invisible to your eye. And change your lenses with the camera facing down in the cleanest environment you can find—you don't want the digital sensor getting dirty. If it does get dirty, save this cleaning job for the professionals. A larger, dry cloth helps wipe away any errant spray on the camera body.

As for filters: sometimes I use them, often I don't—it's a personal preference. A polarizing filter can help reduce glare as will a lens hood.

A backup battery and one or two extra flash cards come in handy. I prefer high-quality cards (e.g., SanDisk Extreme).

I also carry a notebook and pen (the reporter in me) as well as a few photo releases.

As for photo storage, consider storing your collection on a separate external hard drive instead of your computer. This portable portfolio can store all of your photos without taking up room on your computer. The images from external hard drive to desktop or laptop transfer with the click of a mouse.

Protecting Your Camera from the Elements

First, protect you camera from the elements, specifically the likes of rain—even light drizzle and ocean mist. Then, embrace the weather.

As a tourist, you may be in town for a limited amount of time. And although you've planned your trip months in advance, you simply cannot predict the weather. What to do with hazy skies or inclement weather?

Try zooming in on exterior architectural details if you don't want a washed-out sky in your

shot. Blue skies are indeed beautiful but a cloudy day can balance out lighting and a hazy day can sometimes set a mood. Remember, fog can be fun and never underestimate the power of a puffy cloud! And don't forget to practice your nighttime, macro floral close-ups, and people shots, too.

Things to Consider Before You Shoot:

Rules of Composition—Rule of Thirds/Line/ Shape/Balance/Mood/Storytelling

First ask yourself—what am I shooting? What is the subject? Pick a subject and then place it properly. Here's how.

Remember tic-tac-toe? Think of your photo as a rectangular tic-tac-toe board, as a nine-box grid. It doesn't matter if the shot is horizontal or vertical. In essence, you don't want your subject completely centered. You generally want the subject to fall near any of the corners of the center square. This offers balance and proper composition. That said, break the rules—get really close up, completely center something and see what happens—sometimes that works, too!

Use lines and perspective to help draw your eye to the "back" of a photo, such as a fence, a row of houses, a street, or a skyline of buildings. When you change your angle, you change your perspective.

Photographs without borders: take just a part of something. Capture a close-up of something big and let your imagination fill out the frame—it will.

A balanced (photo) diet: add something in the foreground to balance out the background,

Boston is indeed the greatest neighborhood!

such as a bike path cyclist or a bright yellow cab in front of a city building.

Create a mood. Play with your aperture and focus on one particular subject while blurring out the rest of the photo. And don't be so quick with the flash—use existing lighting whenever possible for a unique result.

Rely upon your intuition. Take a break from the automatic settings and tell the camera what to do—and not the other way around.

Finally, tell a story. One of my favorite shots of all time is of two tourists, umbrella in hand, venturing out about the antiques stores in Old Quebec City. Nothing, not even bad weather, could keep them from a day of sightseeing and souvenir shopping. Don't be afraid to include people in your photos. Some are camera shy, yes. But others don't mind if you snap away. Either way, always get permission. Avoid overly posed shots as well.

Visualization/Decisive Moment/Survival Tips on Clichéd Subjects

Think before you shoot. In essence, slow down and take some time before you click the shutter.

Scope out your subject. Are you shooting a stationary object like a building or a statue? Give it a complete front, sides, and rear walk-about.

Timing is everything. Are you shooting fireworks? Anticipate the explosion. Batter up? Wait for the swing. A building often looks nice. A building with a passerby can sometimes look better. Get a person in the shot as he or she walks on by.

There are plenty of photo ops out there—even if it seems a subject has been shot to death. Try to be creative and change your point of view and perspective on life. Photographing children or animals? Come down to their level. Or rise above the photo occasion at hand and capture a bird's-eye view from a balcony.

Try zooming in for architectural detail in-

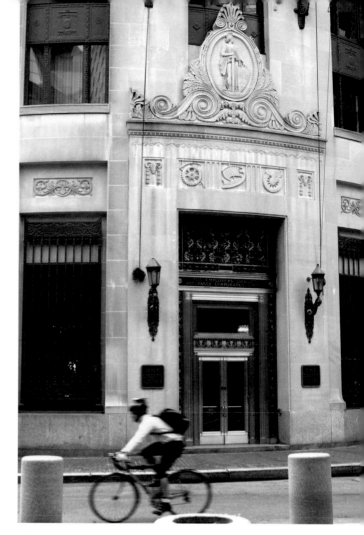

The One Liberty Square Building in the Financial District

stead of taking the whole shot of that famed landmark.

In addition, look at your own portfolio. Do you tend to shoot more horizontally? Then turn that camera on its side and vary your shots between horizontal and vertical.

My favorite tip of all: Change the time of day you shoot. If you're not getting the shot you anticipated, walk away and come back later in the day or early the next morning—you may capture an image that people envy. I love dawn and particularly dusk because a little mood lighting

Old North Church

can go a long way—the camera can capture more light than your eye can see.

Play, play, play with your camera. Brainstorm, be creative, and experiment. And most of all have fun—you may be delightfully surprised with the result.

Resolution

High-res or RAW—what resolution setting is best for you? Again, finding the home for your photo will help you decide what res is best for you.

RAW files capture images in their purest digital form. That saved file lets you post-process the image in many different ways after you've taken the initial shot. But RAW images take up a lot of space.

If you need to do a lot of post-processing to adjust the photo for any number of reasons

such as lighting, exposure, contrast, or are using the photos in a professional way and have ample room on your computer—RAW is the way to go. That said, when I submit photos for my local newspaper assignments—and many for this book—a high-res JPEG is all that's required.

Some cameras take a JPEG and a RAW combo as well as a JPEG and a smaller RAW version, whereas some preselected settings won't capture RAW files at all. In addition, software to convert RAW to other file types is necessary. For personal photo scrapbooks, a large-file JPEG is fine.

After You Shoot—Digital Post-Op Surgery for Photos: Exposure Adjustments

In a perfect photographic world, you take the shot, download it to your computer, and ad-

mire your awesome creativity. Well don't pat yourself on the back too fast. Unfortunately some of those photos may need a bit of cleaning up.

I can't tell you how often I thought I selected proper light settings and composition when capturing that perfect image—even with viewing the LCD screen just after taking the shot (on a sunny day that screen isn't always so easy to see).

If you've underexposed or overexposed a photo—we all do it—don't fret. In the field, adjusting your f-stops will help balance the lighting. But if you didn't get the proper exposure settings out in the field, all is not lost. Play with Photoshop tools such as Levels, Curves, brightness, and contrast to properly adjust exposure and color problems.

Cropping is an easy fix. You can eliminate the likes of an errant power line, ugly smokestack, or unseen garbage can that made its way into your photo. Improve your photos by embracing the software technology and the things you can do after you've taken the shot. That said, don't spend all day being a Photoshop slave. Instead, get out there and shoot!

Photo Ethics, Photo Releases, Photo Permits

Please be considerate of your surroundings, specifically the people you photograph (simply put, leave the paparazzi-style photo tactics for those dopes on TV—way too stressful for me—photography is supposed to be *relaxing*).

It's always a good idea to carry a few blank photo releases with you at all times (free forms are available online). Why? Because your eye for the public may legally be in the public eye—as long as you get permission. If you snap a photo of someone—even if the shot was taken in a public space—it's a good idea to get the person's written permission in case you want to reproduce the image for commercial pur-

poses. Also be careful of corporate logos that crop into your shots if you're using the photo commercially.

In addition, many museums and private properties require permission or permits when shooting commercial photography. These are best checked on an individual basis.

Overall, use common sense when photographing strangers.

Keeping Track of What You Take

Before you know it, a friendly little reminder alerts that your flash card is full. Uh-oh, time to download all those photos. And they do add up—a flash card can hold hundreds of photos at a time. New camera software and fast-processing computers make downloading a breeze. Naming each photo—now that's a different story (not that I'm a high-falutin' *arteest* or anything, but I have many photos titled "Untitled"). Be diligent about properly labeling your photographs. Try labeling your folders and photos by date, place, or subject—or a combination of the three. It's also okay to delete the duplicate and unwanted photos in your portfolio.

Practice and Patience

I take many photos when in the field. But with each new photo I vary the aperture, shutter speed, and ISO settings. Why? That good result from one shot can sometimes ensure a better result on the next (more specifically, less postprocessing, and I'm all for that). Remember, automatic shooting is okay—especially to see what the camera is reading, but manual settings keep you in control. The bottom line: Learn these camera basics on your own equipment and have fun experimenting. And don't be so quick to delete while in the field. Embrace your photographic accidents as you may be delightfully surprised with the results when you're able to see the image on a larger screen.

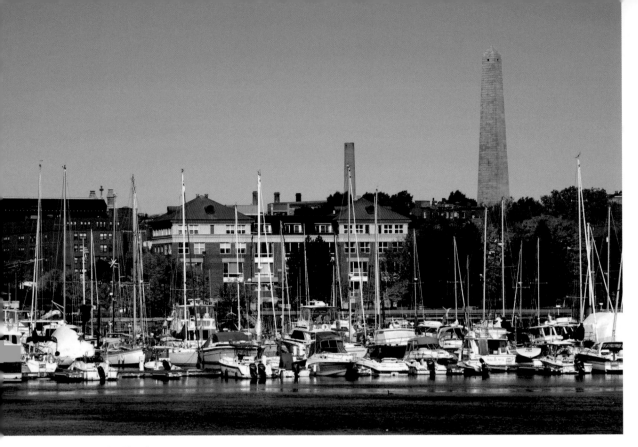

Scenic Charlestown

I. Charlestown

General Description: Charlestown is a great introduction to Boston, with a number of fine photo ops all within close proximity in a neighborhood and seaside setting.

Directions: From North Station (Green or Orange line), exit at Causeway Street and walk east toward the Charlestown Bridge. You'll soon see the red-painted Freedom Trail on North Washington Street—follow it across the bridge into Charlestown. These directions will bring you to all of Charlestown's listing mentioned next. Exact addresses are supplied with each entry.

1. Zakim Bridge

In a town so historically old we start with something abstract, shiny, and new—and a fantastic photo op at that.

When you think of Boston, baked beans and the Red Sox immediately come to mind. But the Zakim Bridge?

Officially known as the Leonard P. Zakim Bunker Hill Memorial Bridge, this Big Dig byproduct was completed in 2003. It spans the Charles River for just a short stretch and connects Charlestown with the North End.

The design offers clean crisp white cables

that pop against a bright blue sky by day. Return at night to find the bridge strategically spotlighted and all aglow. No matter what time of day you shoot, the Zakim Bridge is a fun photographic study of geometry and lines.

Morning shots will leave the sun at your back when taking photos from the North End neighborhood border or on the neighboring Charlestown Bridge, which runs parallel and has a pedestrian walkway (while the Zakim Bridge does not).

Once in Charlestown, Paul Revere Park just off Water Street is another roomy vantage point from which to capture this sleek feat of engineering. The Travel Channel recently ranked the Zakim Bridge ninth in its World's Top Ten Bridges list. This architectural abstract gem is sure to become a Boston architectural icon.

www.leonardpzakimbunkerhillbridge.org

2. Charles River Views/Hoosac Pier

A view from the bridge! While traversing the Charlestown Bridge from Boston's North End en route to Charlestown, pause halfway to get an elevated view of a lovely scenic portion of the Charles River and Boston Inner Harbor. This view comes complete with a line of sailboats docked at the Hoosac Pier and marina in the foreground and the nearby Bunker Hill Monument, which stands at heroic attention in the background.

Because you face northeast from this bridge view when capturing the docks and marina below, you don't want to get there too early in the day for the sun to cooperate fully. That said, you may already be in the neighborhood to shoot the Zakim Bridge mentioned above—the choice is yours. Although you can set up a tripod, the Charlestown Bridge's pedestrian

Where: A short walk across the Charlestown Bridge (there's a pedestrian pathway) from the North End neighborhood

Noted for: a Bunker Hill beacon, harborscapes, military might, and a sculptural soaring feat of engineering

Best Time: Year-round

Exertion: Minimal, for a lot of walking on mostly level terrain—wear comfortable shoes or sneakers nonetheless; a maximum exertion level goes to climbing the Bunker Hill Monument to the top with all your camera gear in tow.

Parking: It's a residential neighborhood, so parking can be tricky. Public pay lots are available in the Navy Yard.

Sleeps and Eats: Marriot Residence Inn Boston Harbor indeed offers accommodations directly on the harbor front—or at least part of the Charles River (617-242-9000). Sample spectacular blueberry scones at Sorelle, which offers breakfast, sandwiches, coffee, and snacks at two Charlestown locations: One Monument Avenue and 100 City Square (www.sorelle.com). (Save your larger appetite for excellent Italian fare just a neighborhood away in the North End, see chapter 2).

Public Restrooms: The city of Boston has installed a half-dozen or so automated public toilets throughout the city. Ten minutes of toilet time will set you back 25 cents. And they're quite clean—in fact, they clean themselves (where do I order one?). There's one located in Charlestown near Dry Dock 2 and Shipyard Park. The Boston National Historical Park Visitor Center also has restrooms.

Sites Included: Zakim Bridge, Bunker Hill Monument, Charlestown Navy Yard

Area Tip: Popular with tourists; be prepared for a little company come high travel season.

walkway is indeed part of the Freedom Trail, so expect some company.

3. Local Parks and Public Art: City Square Park

Small public parks and squares dot the Charlestown residential neighborhood and Navy Yard here and there. Many of these public spaces provide inspiration through works of outdoor art, fountains, monuments, and sculptural architectural highlights.

Just after the Charlestown Bridge you'll find City Square Park (bordered by Rutherford Avenue, Chelsea Street, and City Square). This 1-acre urban park is steeped with local history—it dates from 1775 as an open public space and even earlier—from 1629—with its former name of Market Square. Architectural elements of note include gaslights, winding paved pathways, landscaped borders, a central fountain, and the archaeological remnants of the Great House/Three Cranes Tavern, a Massachusetts Bay Colony–era public building turned watering hole that provided local sea mariners a place to rest their bones and something to drink. The Freedom Trail runs right through the square.

4. Freedom Trail: Bunker Hill Monument

The Bunker Hill Monument at Breed's Hill commemorates the site of the first major battle of the Revolutionary War on June 17, 1775.

Operated by the National Park Service, this hallowed ground features an exhibition space, but the main photo op is indeed the monument obelisk, which stands some 20 stories or 221 feet tall—about half the size of the Washington Memorial, according to the friendly, helpful

City Square Park fountain detail

guides on hand. The obelisk dedication dates from 1843.

Get up close for an abstract of white granite obelisk and bright blue sky to fill the frame. For a medium shot, include the plaza's statue of Colonel William Prescott, a colonial army leader, to the foreground. You will have to play with exposure levels and f-stops to balance out available lighting and properly capture the statue's visage details. Walk around the entire perimeter of Monument Square, the square block of streets that surround the grounds, for a variety of angles. This shot actually lets you squeeze in the entire obelisk while adding a variety of foreground elements, including trees, ornate wrought-iron fencing, the actual hill part of Breed's Hill, as well as visitor silhouettes to add perspective of size.

Visitors can climb all 294 steps for a bird's-eye view of Boston and the immediate Charlestown neighborhood. However, lug your equipment at your own risk, as it's a dizzying spiral climb to the top. Unfortunately, the scenic skyline views shot from the peak are impeded by Plexiglas windows. Expect a crowd during high tourist season.

Bordered by Monument Square.

Admission is free. Hours are 9 AM to 5 PM (last climb departs at 4:30 PM).

www.nps.gov

If you can't get enough of this history lesson, visit the Bunker Hill Museum across the street (43 Monument Square), which is run by the Charlestown Historical Society (visit www.charlestownhistoricalsociety.org).

5. Charlestown Architecture: Buildings of Note

The Charlestown neighborhood offers residential streets lined with historical buildings as well as waterfront warehouses-turned-condos (more on those next). Architectural details abound throughout the area with the likes of

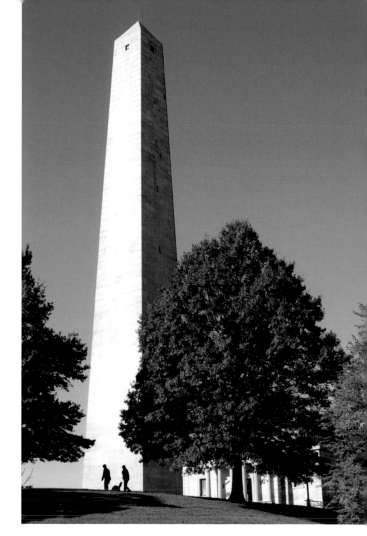

Bunker Hill Monument shot at f8, 1/125th

bay windows, brick façades, and cobblestone sidewalks all painting a colonial-era picture (you'll see many fine examples en route to the Bunker Hill Monument along Monument Avenue).

After your City Square stroll, St. Mary's Church, at the corner of Warren and Winthrop streets, features intricate interior wooden details of a hammerbeam arched ceiling worthy of a shot.

The Warren Tavern (2 Pleasant Street; 617-241-8142; www.warrentavern.com) is the

Charlestown Navy Yard's Muster House shot at f10, 1/200th

oldest tavern in Massachusetts—it dates from 1780 and was frequented by Paul Revere and George Washington. You can grab a burger and a beer (but don't blame me if the rest of the day's photos are out of focus!).

The former Charlestown High School building, on Monument Square near Bartlett Street, offers a neoclassic façade in granite with stately columns. It dates from 1907.

6. Freedom Trail: Charlestown Navy Yard

The Charlestown Navy Yard was as an active shipbuilding facility from 1800 to 1974. Today, the space falls under the administration of Boston National Historical Park of the National Park Service. There are a number of photo ops to keep you busy.

Waterfront scenes abound. A number of dry docks offer playful perspective and a view of the Charles River and Boston Inner Harbor in one direction, and the Bunker Hill Monument in the about-face background. Vintage advertisements here and there add nostalgic fun to the frame, while the Massachusetts Korean War Veterans Memorial in Shipyard Park supplies its own solemn tribute.

A good place to start your visit is at the Charlestown Navy Yard Visitor Center, which is open daily year-round. Come summertime, the place teems with tons of tourists. More on the Navy Yard's buildings and boats are mentioned in the next two entries.

Access the Navy Yard along Chelsea Street or Constitution Road.
Admission is free.
Call 617-242-5601 (Visitor Center).
www.nps.gov/bost

7. Charlestown Navy Yard: Industrial and Historical Architecture

A study of industrial-style architecture rules the photo frame when visiting the Navy Yard.

The art of exploring photo perspective, angle, and shape is easily explored at any number of buildings that offer architectural elements such as warehouse-style windows (sometimes broken), peeling paint, door archways, and lines of rooftop exhaust fans.

Many of these industrial forge shop, timber shed, and supply building remnants have been transformed into condo dwellings in the past few decades and have been updated, so please be considerate of the area's residents. You'll find these blocklong behemoths bordered along 1st and 5th avenues and 6th and 16th streets east of the main visitor center.

Make your way between the buildings at 8th and 9th streets closest to the waterfront to find the geometric skeletal remains of a once-standing structure, a shed, I think, which now serves as a white-steel-frame and blue-sky abstract work of art.

Other prominent Navy Yard edifices worthy of exploring include the octagonal Muster House (at 5th Street and 2nd Avenue) and the Commandant's House, which overlooks Dry Dock 2.

8. Boats of Note: USS *Constitution*/ USS *Cassin Young*

What's a shipyard without some boats to photograph?

Both history and military might are highlighted in the USS *Constitution* and the USS

A vintage advertisement at the Charlestown Navy Yard

Cassin Young. Both are available to photograph at your Charlestown Navy Yard visit.

The USS *Constitution,* nicknamed "Old Ironsides," was launched in 1797. It is considered the oldest commissioned warship still afloat on the high seas—or at least now Boston Harbor, says the National Park Service. To tour the frigate, you have to pass security screening. On busy summer days, expect at least a one-hour wait. You can still capture the boat from the dock if you don't want to wait in line.

Also moored a dock away is the USS *Cassin Young,* a World War II destroyer, which now serves as a historical memorial or museum ship. Visitors are allowed to roam the deck and some of the interior cabins. The steel gray ship, a bright blue sky, and a variety of naval flags create a colorful mix to the frame. Photography is allowed on the ship but there's no room for a tripod. Again, expect a crowd during high tourist season. That said, I visited in the fall and enjoyed no wait at all.

Visits for both are free.

The USS *Constitution* is open from 10 AM to 4 PM Tuesday through Sunday during summer and Thursday through Sunday during winter.

The USS *Cassin Young* is open from 10 AM to 5 PM during high season. Winter hours are daily but weather permitting. Below-deck tours are also held daily.

Visit www.nps.gov. Also visit the USS *Cassin Young* volunteer Web site at www.dd793.com.

The USS Cassin Young *is located at the Charlestown Navy Yard*

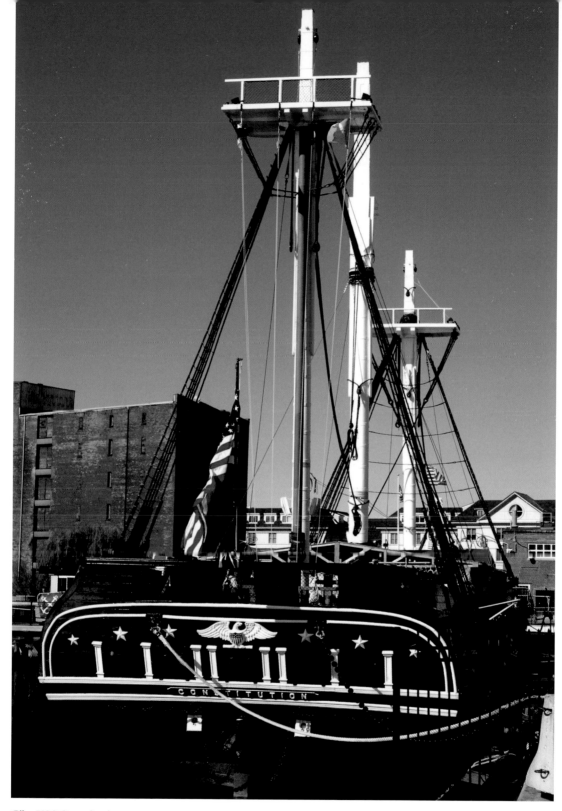

The USS Constitution

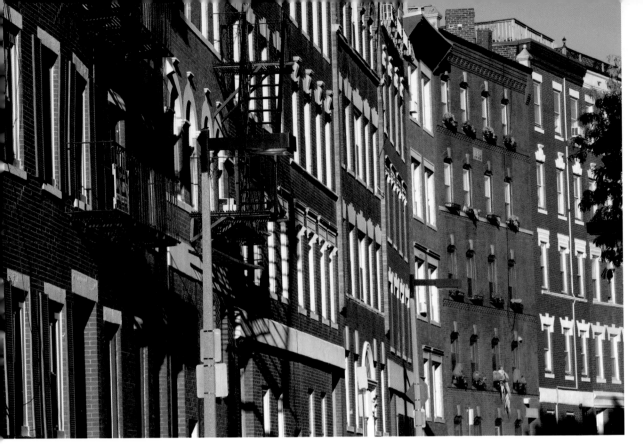

North End architecture

II. North End/Aquarium District

General Description: The North End is basically Little Italy—a decent restaurant is never far away. As you venture just south of this neighborhood, you'll enter the Aquarium district, which hugs the harbor front toward the east and the downtown core south and west. You can easily create your own itinerary combining parts of this chapter and chapter 3.

Directions: The Green Line gets you to North Station to the north; the Blue Line gets you to Aquarium station to the south; the Orange or Green line gets you to Haymarket station somewhere near the middle. Also take the seasonal Salem Ferry to Boston's Long Wharf near the Aquarium (www.salemferry.com).

9. North End Architecture: Streets and Storefronts

The North End is Boston's oldest residential neighborhood. Folks have been living in these parts since the 1630s.

These narrow North End streets provide rows of apartment houses that stretch to the back of the frame with a variety of angles. Alleyways and fire escapes add further photo exploration.

Practice textbook perspectives along the

likes of Endicott, North Margin, Prince, and Hanover streets. Many of these streets add strings of colorful garland decorations during Italian festival season. Capture iconic storefronts complete with bright red neon signs at such eateries as Modern Pastry and Pizzeria Regina. Also don't miss the Skinny House at 44 Hull Street. No, it's not someone's name, it's just happens to measure in at a mere 10 feet wide.

> The North End is bordered generally by Commercial Street to the north and east and I-93 to the west.
> www.northendboston.com

10. Freedom Trail: Copp's Hill Burying Ground

Copp's Hill Burying Ground, a designated Freedom Trail stop and included on the U.S. National Register of Historic Places, dates from 1659. It is considered the second oldest of Boston's cemeteries after King's Chapel. Buried in the hallowed space are many African Americans who worked at the nearby Charlestown Navy Yard.

Rows of centuries-old tombstones in this small cemetery offer a simple study of perspective in your photo frame. Close-up tombstone shots provide an exploration of unique shapes, still-legible engravings, and chipped slate surface detail. For added atmosphere, add dramatic summer sunsets or colorful fall foliage to the frame. You can also squeeze in the Old North Church steeple into the background of some shots.

> Access the Copp's Hill Burying Ground along Hull Street between Snow Hill and Salem streets.

11. Freedom Trail: Old North Church

Two if by sea. The Old North Church, which dates from 1723, is the oldest church building in Boston. A historical landmark, the church is where two lanterns were hung in its steeple on that fateful night of April 18, 1775, during Paul's Revere's famous midnight horseback ride from Boston to Lexington. The two-lantern signal indeed meant that British troops were arriving by sea and not by land.

There are a number of challenges when

Where: North and east of the downtown core

Noted for: Colonial midnight rides, Big Dig cover-ups, swimming with the fishes

Best Time: Year-round

Exertion: Minimal for walking

Parking: Street parking comes at a premium in the residential North End neighborhood. Government Center Parking Garage is at 50 New Sudbury Street; Fitz Inn-Auto Park is at the corner of Commercial Street and Hull Street.

Sleeps and Eats: Not North End proper, but not far away in the West End is the Holiday Inn Express (280 Friend Street, 617-720-5544, www.ichotelsgroup.com) across the street from Boston Garden. As for food, you're in luck. You'll find some of the best brick oven–style pizza in town at Pizzeria Regina (11½ Thacher Street, 617-227-0765, www.reginapizzeria.com). Expect a wait to get in at times. Save room for dessert or a tasty souvenir at Modern Pastry (257 Hanover Street, 617-523-3783) or Mike's Pastry (300 Hanover Street, 617-742-3050).

Public Restrooms: A public pay toilet is available at Commercial Street near North End and Langone parks. Restrooms also available at the New England Aquarium.

Sites Included: Old North Church, Paul Revere House, New England Aquarium

Area Tip: The streets wind this way and that, so be prepared to get a little lost. You can avoid any wrong turns by sticking to the Freedom Trail.

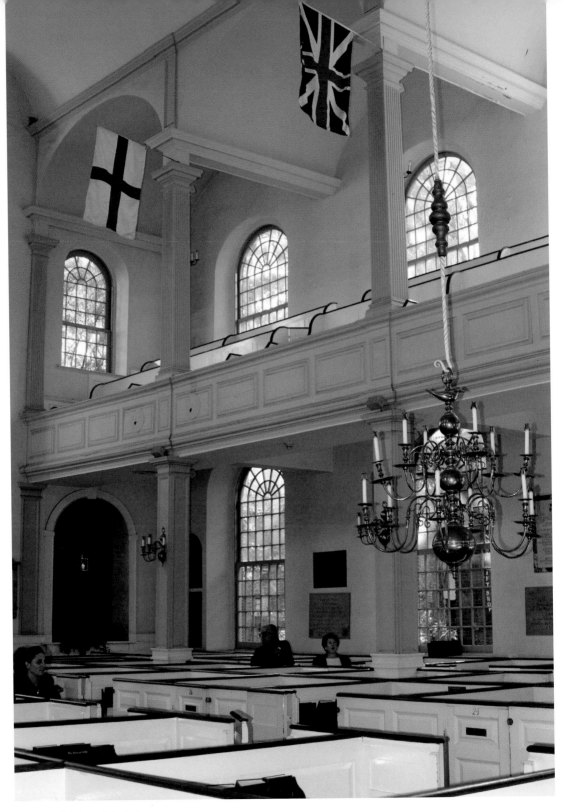

Old North Church interior

shooting this Revolutionary-era historical icon; specifically, there's not much room to maneuver on the surrounding streets and squeeze all that incredible history into the frame. A long view along Hull Street makes the church your focal point, but you'll also get that long line of parked cars in the shot—this is a residential neighborhood, after all. The narrow side-street vantage points create challenges of shadows and light as well. Opt for a sidewalk close-up of façade, steeple, and sky.

Interior shots with flash are allowed. Expect a line of tourists—upward of a two-hour wait come high summer season. Also expect a wait to enter and explore when church is in session, as the Old North Church, officially Christ Church in the City of Boston, is still an active parish and holds Mass daily. Interior behind-the-scenes guided tours are available during summer for a nominal fee.

Other shots include the occasional art installation and a lovely sculpture of Saint Francis of Assisi in the rear courtyard.

At 193 Salem Street.
Take the T: Orange or Green line, Haymarket stop; Green Line, North Station stop.
Call 617-523-6676.
www.oldnorth.org

12. Paul Revere Mall

The Paul Revere Mall pays proper homage to everyone's favorite silversmith and midnight rider.

The tree-lined brick-laid space offers one of Boston's most iconic photo ops: the image of the Old North Church steeple in the background with the statue of Revere with outstretched arm on horseback in the foreground. Although the shot has been captured many times before, it's a deceptive one at that, as white steeple, bright blue skies, green treetops, and the black silhouette of the monument's fig-

ure all compete for exposure levels—not to mention the tons of tourists looking to capture the same shot and jockeying for position in front of the statue.

The mall connects the rear of the Old North Church at Unity Street to Hanover Street.

Paul Revere Mall shot at f5.6 at 1/125th

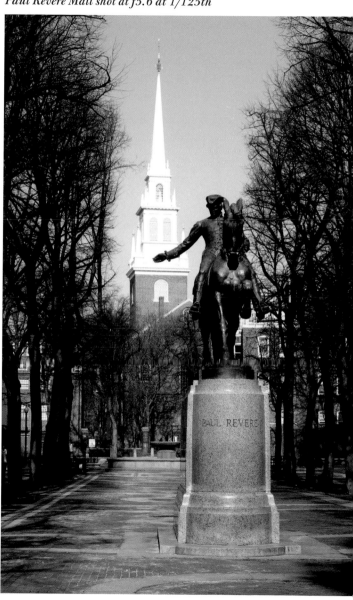

The Paul Revere House

13. Freedom Trail: Paul Revere House

After your Paul Revere Mall visit, follow the Freedom Trail to his house, which dates from about 1680 (the Reveres lived there from about 1770 to the turn of the 19th century). It is considered the oldest house in Boston.

Although it's an official Freedom Trail stop, the Revere House and the neighboring Pierce/Hichborn House are privately run museums—that means a nominal admission fee is charged. The dual facility is administered by the Paul Revere Memorial Association.

Although there's a wait during high tourist season, and picture-taking is prohibited inside, photography is permitted in the colonial-style courtyard. The exterior is definitely worth a shot, specifically when including the house into the frame with the perspective of the North Square street scene. Depending on the time of year, be prepared for more than a few folks in the frame as well, as sidewalks in these parts overflow come summer. The houses face southeast, so the sun is at your back by midday.

> At 19 North Square
> Take the T: Green Line, Government Center or Haymarket stops; Blue Line, Government Center or Aquarium stops; Orange Line, State or Haymarket stops.
> Admission costs about $3.50.
> Call 617-523-2338.
> www.paulreverehouse.org

14. Rose Kennedy Greenway

Once upon a recent time in Boston there was the Big Dig, a very expensive construction undertaking by the city that buried the once-

elevated highway system underground. After the project was completed, the city covered the Big Dig with lush green urban park space.

Officially titled the Rose Fitzgerald Kennedy Greenway, the 15-acre four-park system meanders its way through a number of downtown neighborhoods, including the North End, the Wharf District, Dewey Square, and Chinatown. It runs about 1 mile long and measures about as wide as the buried Interstate 93 highway tunnel that it covers.

The landscaped property provides paved pathways, manicured gardens, tree-lined promenades, and outdoor modern sculptures, all of which provide unique foreground elements to the city skyline background view visible at every turn.

The North End sector park plaza provides waterworks, people watching, and a perspective toward the Zakim Bridge. The Wharf District gets a little misty with its Harbor Fog installation near Milk and India streets. Also look for the lyrical skyward sculpture titled *Botanica* by artist George Sherwood across from the Rowes Wharf Hotel, an architectural photo op in its own right.

> From north to south, the Greenway stretches from Haymarket Square to about Beach Street along Cross Street, Atlantic Avenue, and then Surface Road.
> www.rosekennedygreenway.org

15. Christopher Columbus Park

If headed along the Greenway after your North End stroll but before your aquarium visit, take a break at Christopher Columbus Park.

Mostly a small, open, green space, Christopher Columbus Park provides a simple but

The Greenway near the North End and downtown

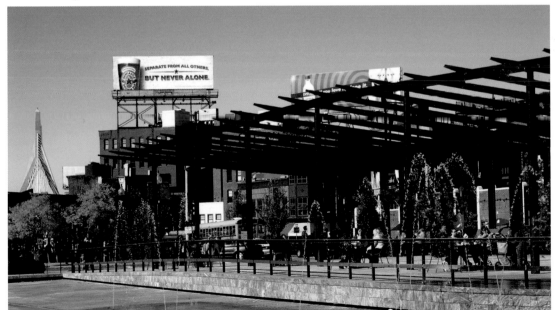

deceptive photo challenge in the form of a centerpiece wisteria-covered trellis. The shot offers line and perspective, playful silhouettes of visitors perched at any number of park benches, and exposure challenges of bright background waterfront lighting and shadows beneath the covered walkway.

At Cross Street and Atlantic Avenue.

Take the T: Blue Line, Government Center or Aquarium stops.

16. New England Aquarium

Swim with the fishes—or at least photograph them up close—without getting your gear wet!

The New England Aquarium, one of the country's leading aquarium facilities, has been educating the public about marine life through onsite visits as well as a number of research and conservation efforts since 1969. Colorful photo subjects include tropical fish, penguins, stingrays, sea urchins, jellyfish, and octopuses, to name a few. The sea creatures on hand number some 600 species; 20,000 animals in all.

Photography is allowed in the exhibition space with flash, but tripods are prohibited. Be aware that the flash may interfere when shooting through the thick panes of aquarium tank glass. Add about $14 to your admission price for a guided behind-the-scenes aquarium tour that also allows photography.

In season, early April through late October, take to the high seas on an aquarium-sponsored four-hour whale-watch cruise aboard the *Voyager III* to the Stellwagen Bank National Marine

The New England Aquarium

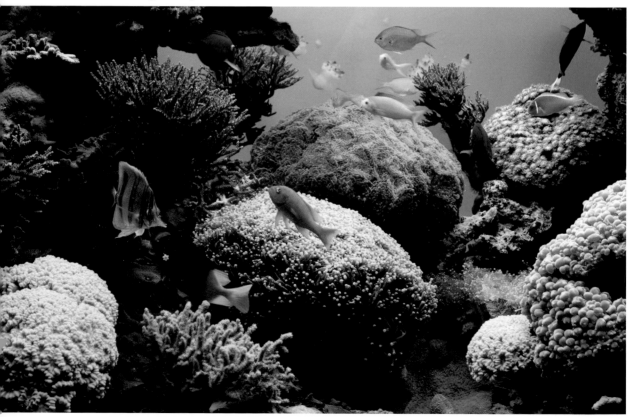

Seaside scenery abounds along Boston's HarborWalk

Sanctuary. Photography is allowed on the cruises—just protect your camera from the ocean spray. Whale species often spotted include humpback, finback, pilot, and minke whales, as well as the endangered right whale.

At 1 Central Wharf
Take the T: Blue Line, Aquarium stop.
Admission costs about $20.95 for adults.
 Aquarium and Whale Watch combo costs about $52.95. Open daily (except for Thanksgiving and Christmas).
Call 617-973-5200.
www.neaq.org

17. Wharves and Waterfront Scenery/Boston HarborWalk

Where there's an aquarium, there's water. Where there's water, there's a wharf or two. In Boston, there are plenty of places to capture serene river, harbor, and oceanfront scenery. The Aquarium District is one of them.

Long Wharf offers plenty of room to set up a tripod at wharf's end. Any number of seagoing watercraft may appear to fill the frame. If you prefer to take the town from the boat's perspective, hop on board Boston Harbor Cruises or the Provincetown Fast Ferry, both accessible from Long Wharf. If you really like the area, stay at the Marriot Long Wharf located directly on the wharf itself. Just next door is Central Wharf, home to the aquarium.

And whereas Boston's city streets enjoy historical stops and photo ops along the Freedom Trail, Boston's waterfront enjoys HarborWalk, which offers designated paths, promenades, boardwalks, wharves, and beach strolls that run along Boston Harbor in Charlestown, the North End, Downtown, Fort Point Channel, South Boston, and Dorchester.

The Boston HarborWalk Web site, run by the Boston Harbor Association, provides maps, links of things to do, and where to find outdoor art to add to the frame.

www.bostonharborwalk.com

Beacon Hill doorway

III. Beacon Hill/Government Center/Downtown Crossing/Freedom Trail

General Description: This is government, Freedom Trail, downtown, and tourist central—it's got it all.

Directions: The Government Center stop on the Blue or Green line leaves you in the center of everything. Or just follow the Freedom Trail.

18. Beacon Hill Architecture

Some of the toniest addresses in town belong to the historic Beacon Hill neighborhood of Boston. And that the word *hill* is mentioned in the name indicates there is indeed a slight incline when walking these city streets. The area's cobblestone, sometimes uneven sidewalks mean no high heels, please.

Architectural detail close-ups abound for this photo study of iconic doorways, ornate stained-glass window accents, oxidized bay windows, and black wrought-iron fencing.

And while much of the nearby downtown area lays claim to the Freedom Trail, Beacon Hill offers its own historic walk along the Black Heritage Trail. The Old West Church (131 Cambridge Street) provides another fine shot.

The neighborhood is mostly bordered by Cambridge Street to the north; Somerset Street to the east; Beacon Street, which runs along Boston Common, to the south; and Storrow Drive along the Charles River Esplanade to the west.
Take the T: Red Line, Charles/MGH stop.

19. The Esplanade

From about the Longfellow Bridge near Beacon Hill, Boston's Esplanade hugs the Charles River to the Boston University Bridge well into the Back Bay some 3 miles away, mostly along Storrow Drive.

Need a photo op? The Esplanade's got it all, including people-watching, perspective views of the river, joggers, tourists, windsurfers, willow trees, public art, pedestrian bridges, marinas, and an art deco bandstand shell, just to name a few. One particular sculpture of note is

Beacon Hill storefront

of everyone's favorite Boston pop, beloved symphony orchestra conductor Arthur Fiedler. It's located near the bandstand.

Now before any locals yell at me for including the park in Beacon Hill rather than Back Bay (the space geographically encompasses more of the Back Bay, in fact), I have good reason. This is where you'll find Community Boating, the not-for-profit association via which modern-day seafarers rent those iconic Charles River sailboats for which the city is so famous.

Community Boating rents a variety of watercraft to the general public, including sailboats, windsurfing boards, and kayaks. You can capture an abundance of the boats from the nearby dock and shoreline, or rent a watercraft to get a unique foreground to your Boston skyline shot. There is an application form and an orientation class to complete before you set sail. A one-day sailboat rental costs about $75. The season runs from April through October.

Community Boating is at 21 David Mugar Way.

Access the Esplanade and rental office in Beacon Hill at the pedestrian overpass near where Embankment Road, Silver Place, and Charles Street meet. There's another overpass near Beacon Street and Beaver Place.

Take the T: Red Line, Charles/MGH stop.

Call 617-523-1038.

Head of the Charles Regatta

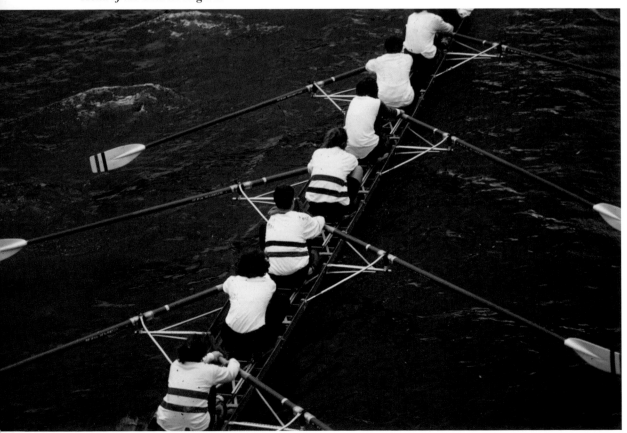

www.community-boating.org

Also visit the Esplanade Association at
www.esplanadeassociation.org.

20. Area Buildings of Note

If urban architecture is your thing, you've
come to the right place.

Boston's downtown core provides a mix of
colonial old and glass-and-steel-skyscraper
new. While Freedom Trail architecture and
Boston's more prominent structures get their
own entries, here are a few others in the area
that I had fun capturing on film. A word of
note: The buildings not only include the
Government Center vicinity, but prominent
nearby Financial District structures will no
doubt enter into the frame.

A tree-lined perspective of the immediate
skyline can be captured when facing south at
Causeway Street near North Station/Boston
Garden (the Zakim Bridge will be at your
back). The JFK Federal Building (15 New
Sudbury Street) presents a playful geometrical
façade worthy to explore. Adjacent to City Hall
Plaza, the 1-2-3 Center Plaza Building along
Cambridge Street has a cool curved façade that
softens the hard right angles of the area's sky-
scrapers.

Then across from City Hall headed east, the
Union Oyster House (41 Union Street, 617-
227-2750, www.unionoysterhouse.com), with
its prominent neon sign, and the neighboring
Yankee Publishing Building, add colonial flair
to the photo. (Stick around for a bowl of chow-
der at the Union Oyster House.)

21. Boston City Hall

Depending on your architectural point of view,
there are many terms to describe the stylistic
sensibilities of Boston City Hall: *imposing,
grand, daunting, eyesore,* and *oh-so-'70s*—it
was actually completed in 1968. It's a testa-
ment to brutalist-style concrete in all its build-

JFK Federal Building

ing glory—you either love it or hate it. For a
photo study, I happen to adore it, as it's full of
clean lines, geometry, and light and shadow
play. That said, many Bostonians take an un-
kindly view of the building.

The generous plaza offers plenty of room to
set up a tripod, as well as provides people
watching at its best.

At Tremont, Court, and Cambridge streets.
Take the T: Blue or Green line;
Government Center stop.

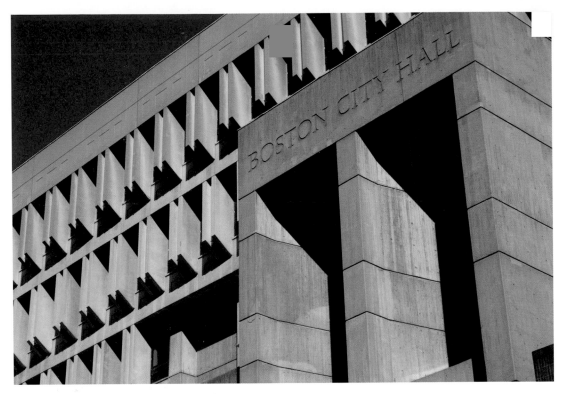

Boston City Hall

22. New England Holocaust Memorial

The New England Holocaust Memorial was dedicated in 1995 as a solemn reminder of dark days past and of future times full of remembrance and hope.

The main feature is a procession of six stately glass towers that soar skyward to a height of 54 feet tall. By day, you can capture the towers from within for a study of geometry, shape, and blue sky. Some 6 million numbers float like transparent spirits etched within the glass. At night the towers are lit from below.

The visit lingers in your mind long after you leave.

> The New England Holocaust Memorial is bordered by Congress, Hanover, Union, and North streets, adjacent to City Hall Plaza.

> Take the T: Blue or Green line, Government Center stop.
> www.nehm.org

23. Freedom Trail: Faneuil Hall/ Quincy Market

You can practically hear the cries of the colonists en masse shouting for liberty and freedom—oh wait, that's the tourists clamoring for counter space, ordering food, and bargaining for a lobster-shaped refrigerator magnet souvenir.

It's not easy to capture Faneuil Hall (say *fan-yul*) or adjacent Quincy Market during downtime, as this is indeed Boston tourist central—but that's what makes this people-watching photo op so much fun. Definitely expect a crowd for this one.

You can opt for Georgian-style architectural

building detail close-ups or add the silhouette of the Samuel Adams statue into the frame. You'll find Adams at the Faneuil Hall front plaza, and lots of street performers and crowds at the space that separates the two buildings.

Stick around for a slice of heaven at Pizzeria Regina or grab a bowl of goodness at Boston Chowda—there are 40 restaurants in all.

At 1 Faneuil Hall Square.

Take the T: Blue Line to Aquarium/Faneuil Hall, Green Line to Government Center, or Orange Line to State Street stops.

Call 617-635-3105.

www.faneuilhallmarketplace.com

From here you can head a block south to State Street to capture some Financial District skyscrapers (see chapter 4).

24. Freedom Trail: Old State House/ Boston Massacre Site

I was first introduced to Boston in 1980 on a field trip as a senior in high school. I made many memories of fun times with classmates and adventures of a new place. But the image that stayed in my mind's eye all of these years was that of the Old State House.

The colonial-era Georgian-style landmark structure, which dates from 1713, served as the seat of government for the Massachusetts Bay Colony. Today, while the building gets dwarfed by a neighboring canyon of concrete, steel, and glass, it is the Old State House that timelessly stands out among its modern-day counterparts.

The red brick façade pops with white ornate trim, molding accents, and fanciful steeple. Standing guard at roof's peak, a replica golden lion and unicorn provide remnants of the old country—the pair is present on the British coat of arms. (I say replica, as the originals were burned to break any ties to the monarchy).

The building is fun to photograph from any variety of angles, but you will have to contend with lots of city traffic as it's located in a busy intersection. A long view from State Street makes the Old State House the focal point of a perspective shot.

In addition, you may also notice the occasional tourist lying flat on the ground at the small traffic island in front of the house—the person is actually lying next to a star-shaped cobblestone brick that marks the spot where the Boston Massacre took place. The building

New England Holocaust Memorial

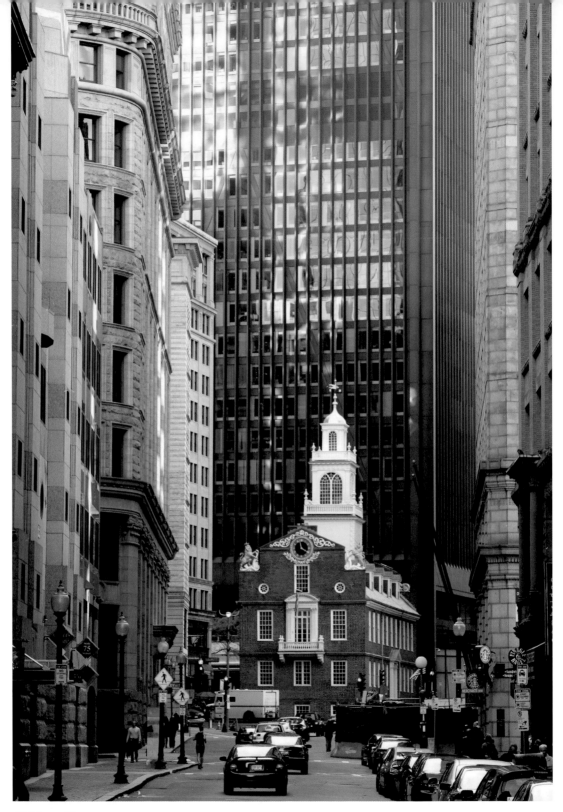

Old State House

houses an onsite museum that further explores the history of a young nation. Photography is allowed inside without flash.

The Old State House is indeed an iconic souvenir snapshot you will remember long after your visit to Boston.

At 206 Washington Street at the corner of State Street.

Take the T: Blue or Orange line, State Street stop.

Admission to the museum costs $7. Open daily.

Call 617-720-1713.

www.bostonhistory.org

25. Freedom Trail: Old Corner Bookstore/ Old South Meeting House

The next few entries finish up the Freedom Trail in photographic style.

The Old Corner Bookstore (3 School Street, 617-367-4004) dates from 1718 as an apothecary. Established as a bookshop and printing house a century later, it was visited often by literary giants Henry Wadsworth Longfellow, Harriet Beecher Stowe, Nathaniel Hawthorne, Ralph Waldo Emerson, Louisa May Alcott, and Charles Dickens, who all had books published on the premises. The shot: From across the Washington Street intersection, you can vertically capture the entire gambrel-roofed façade as well as a few Financial District skyscrapers.

One block south you'll find the Old South Meeting House (310 Washington Street, 617-482-6439, www.oldsouthmeetinghouse.org). Perhaps its biggest claim to fame was that it was the place where the Boston Tea Party was organized. The shot: Venture diagonally across to School Street to vertically frame the Old South Meeting House with the busy Border's bookstore plaza in the foreground. A bonus: You can take shots inside the onsite museum as well ($5 entry fee) without a flash.

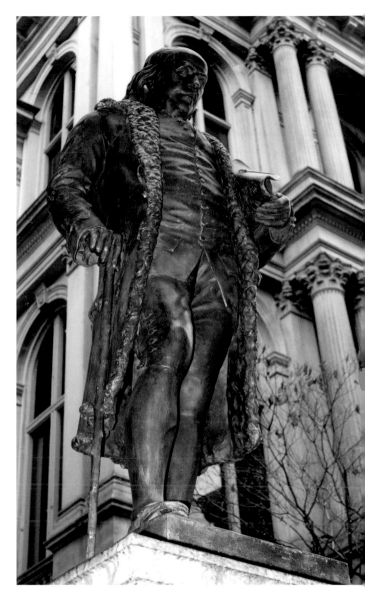

Ben Franklin statue at Old City Hall

26. Freedom Trail: Franklin Statue/Old City Hall/King's Chapel and Burying Ground

Head west, young colonist with camera in hand, down School Street to find the site of the Latin School, the oldest public school in the United States. Alumni include John Hancock, Samuel Adams, and Benjamin Franklin, one of

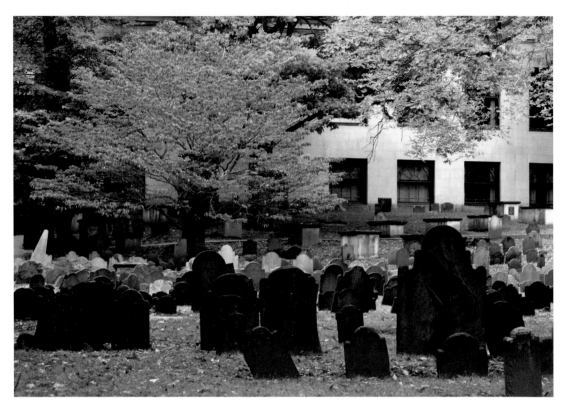

Granary Burying Ground

Boston's favorite sons whose statue rightly adorns the premises (45 School Street). The exquisite French Second Empire–style building that you see served as Boston City Hall from 1865 to 1969. The shot: This one's as equally about Ben as it is the building. And, however you capture Ben, you'll get the magnificent building in the background. Photo tip: Lighting can be tricky. Play with your exposure settings to balance the lot of trees and bright sky to properly capture all of Ben's facial details in the picture.

Continue just west to the intersection of Tremont and Beacon streets, where you'll find King's Chapel and Burying Ground, home of the Anglican Church's first congregation in the colonies. The shot: The front façade with its stately columns works best. A bonus: The active parish hosts the occasional evening music recital.

27. Freedom Trail: Granary Burying Ground/Park Street Church

Interred at the Granary Burying Ground (heading south along Tremont Street) is a who's who of American history. Samuel Adams, Paul Revere, John Hancock, and the victims of the Boston Massacre, among others, all rest in peace here. Photo tip: The main gate may be closed but you can still squeeze the lens through the wrought iron fence. Fall foliage adds dramatic color to the cemetery shot. be sure to about-face to capture the exquisite façade of the Tremont Theater/Tremont Temple (88 Tremont Street).

Neighboring Park Street Church has graced

this corner since 1809. The shot: There's plenty of room at the northeastern corner of Boston Common to set up a tripod and vertically squeeze in all of the church, steeple, and spire. Photo tip: The sun cooperates best during afternoons. And listen for the bells—the carillon sounds twice daily.

28. Freedom Trail: Massachusetts State House

Follow along Park Street to find the Massachusetts State House, one of Boston's most iconic photo ops. The building, completed in 1798, is indeed the state capitol. The shot: You'll have lots of room at the northern tip of Boston Common in which to capture the Beacon Street façade—and that's the one you want as it displays all of the building's best Federal-style assets, including grand Corinthian columns, open-air portico, and signature gilded dome. Bonus no. 1: The sun cooperates with the shot during most of the day. By early evening, you'll sometimes find the golden dome all aglow. Bonus no. 2: Free State House tours are offered on weekdays (reservations required at 617-727-3676). Bonus no. 3: Do an about-face to the park perimeter and check out the intricate ornate detail of the magnificent bronze statue dedicated to Robert Gould Shaw and the 54th Massachusetts Volunteer

Massachusetts State House

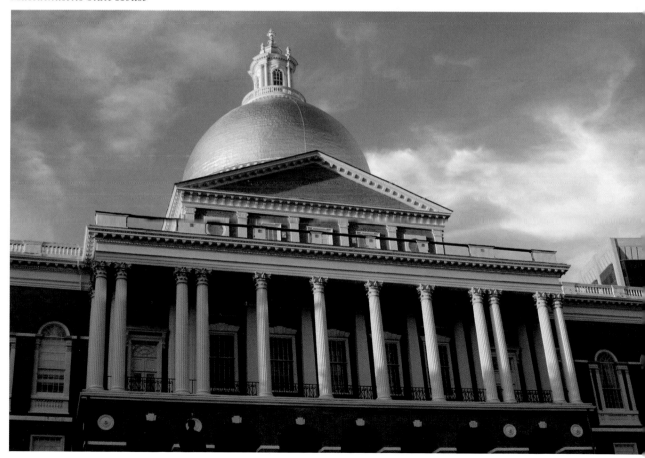

Infantry. It's quite something. Bonus: no. 4: Mingle with a politician or two over breakfast or a burger at Capitol Coffee House (122 Bowdoin Street, 617-227-4865).

29. Freedom Trail: Boston Common/Boston Public Garden

Although they stand side by side, Boston Common and Boston Public Garden tell a tale of two green spaces.

Boston Common, both a Freedom Trail and Emerald Necklace stop, dates from 1634 and is considered the oldest public park in the United States. Photo ops of note here include Frog Pond, which doubles as an ice-skating rink in winter, tree-lined paved paths, the Parkman Bandstand, a number of statues, the Central Burying Ground, and entertaining people-watching in the form of tourists and locals alike. It's also an excellent vantage point from which to shoot the Massachusetts State House.

Travel west across Charles Street, where you'll find Boston Public Garden, which offers a more refined garden atmosphere complete with the stuffy signs to match (such as DO NOT CLIMB THE TREES and PLEASE KEEP OFF THE GRASS). That said, it's definitely worth a visit. Here you can capture a splendid pedestrian lagoon bridge; well-manicured gardens; unique tree species of dawn redwood, ginkgo, and weeping willow; binocular-clad birdwatchers; and Boston's iconic and endearing Swan Boats. These latter are seasonal, in use from April through October.

Boston Common/Boston Public Garden is bordered by Beacon, Park, Tremont, Boylston, and Arlington streets.

Robert Gould Shaw and the 54th Regiment Memorial at Boston Common, by Saint-Gaudens, 1897

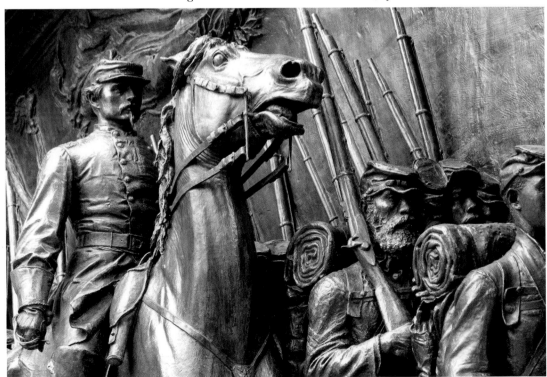

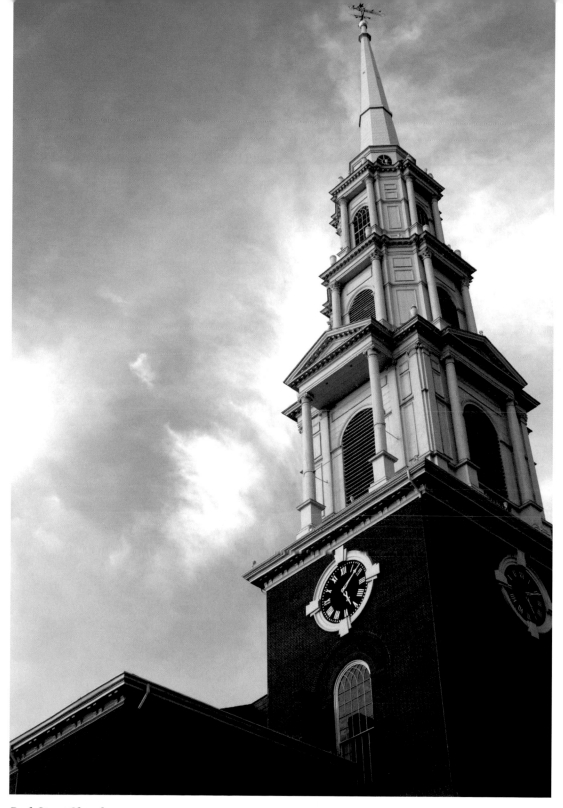

Park Street Church

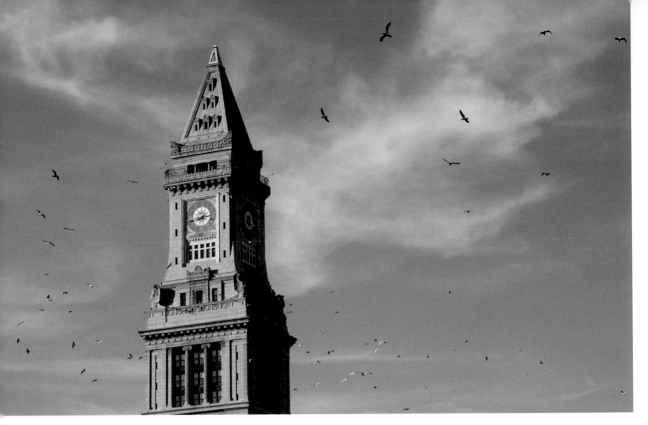

Custom House Tower

IV. Financial District/Theater District/ Chinatown/South End

General Description: Buildings abound in this part of town. Get ready to channel your inner architect.

Directions: The Orange Line T stops of State, Downtown Crossing, Chinatown and New England Medical Center serve the area well. The Silver Line also services the Chinatown stop. Easily transfer from the Orange, Red, and Silver lines at Downtown Crossing.

30. Custom House Tower

All eyes are drawn magnetically to the distinctive Custom House Tower, an almost 500-foot edifice that pops above Financial District streets in neoclassical style—it's one of the most recognizable buildings on the Boston skyline. The original building, specifically the base, has a stately columned façade and dates from the mid-1800s. The tower was added later and completed in 1915. The building acted as the Boston Custom House until the 1980s. Today it's a Marriott Hotel property.

You can capture it up close for a shot of the magnificent clock tower. I also managed to get an intriguing shot of the tower from the Greenway near Rowe's Wharf just to the east.

The shot included subtle wisps of clouds, a bright blue sky, and birds buzzing about like bats attracted to their belfry.

At 3 McKinley Square.

Take the T: Blue Line, Aquarium stop. Call 617-310-6300.

www.marriott.com

31. Other Area Hotels of Note

The InterContinental Hotel (510 Atlantic Avenue, 617-217-5030, www.intercontinental boston.com), which hugs the South Boston waterfront in the Financial District, offers playful reflection with its all-glass façade.

More abstracts in glass can be further explored at the always über-chic W Hotel (100 Stuart Street, 617-261-8700, www.whotels .com) in the Theater District.

Also in the Theater District: the distinctively triangular Park Plaza Hotel and Towers (50 Park Square, 617-426-2000, www.park plaza.com), located where Eliot Street, Columbus Avenue, and Park Plaza converge, evokes New York City's Flatiron Building. Take this shot directly in front to play with shape and sky.

32. Art Deco Architecture

The Boston Financial District boasts a few art deco architectural gems, all of which are conveniently located along the perimeter of Post Office Square centered at Congress, Franklin,

Financial District scene

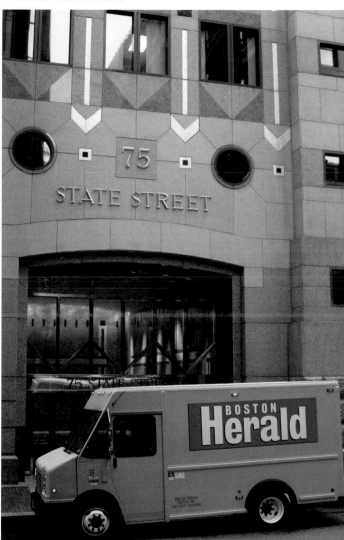

Financial District buildings

ner of Kirby Street) boasts bold art deco golden arrow accents that provide some photographic punch to the shot.

And while you may be drawn to the exquisite stylings of the John W. McCormack Post Office and Court House (5 Post Office Square), a federal government building built in 1933 at the height of the Great Depression, security shunts you aside if you try to take a close-up shot of the façade from the sidewalk directly in front (it's a Homeland Security thing, so I was told). It's nonetheless simple enough to include the building within an area panorama.

33. Other Area Buildings of Note
Office towers and vintage edifices reign in this area.

Adjacent to the aforementioned Fleet Bank Center , you'll find Exchange Place (53 State Street), a lyrical, subtle, sculptural glass masterpiece worthy of a few shots from near and far. (This was one of my favorites to play with, photography-wise.)

Just around the corner, Liberty Square, at the convergence of Kirby, Water, and Batterymarch streets, features the Hungarian Revolution Memorial, which commemorates a 1956 student uprising. The monument makes a perfect foreground element with which to capture the One Liberty Square Building, which dates from 1926.

Heading back toward the Verizon Building, I came upon a fun geometric pattern of right angles and triangles that served the frame well at the intersection of Congress and Matthews streets, facing southwest. I don't know all of the towers in the mix, but most prominent was the back of 100 High Street.

34. Theaters of Note
If a marquee is on your mind, make your way to Boston's Theater District. It may not be Broadway, size-wise, but the production values

Pearl, and Milk streets. The Norman B. Leventhal Park adds a lush green urban space to the foreground.

The Verizon Building (185 Franklin Street) drips with decorative accents down to the fanciful art deco phone booths—yes, some do still exist.

Although constructed in 1988, the 75 State Street Building (Fleet Bank Center at the cor-

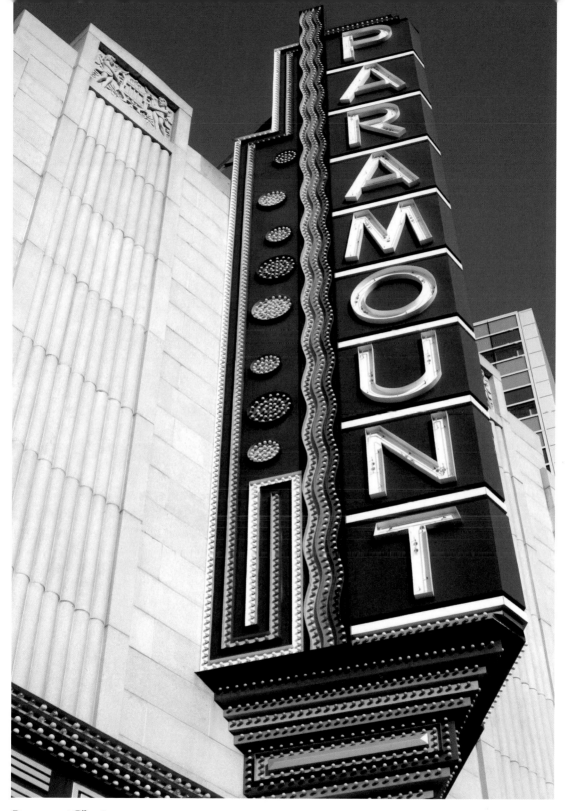

Paramount Theatre

found in Boston easily rival the Great White Way. Many of the theaters run along or near Tremont and Washington streets. The Orange Line Chinatown stop and the Green Line Boylston stop on the T get you close.

The Paramount Theatre (549 Washington Street) features a fancy art deco look and a marquee that explores a simple study of the primary colors.

Chinatown Bamboo Garden

The Boston Opera House (539 Washington Street, 617-259-3400, bostonoperahouseon line.com) façade oozes with elegance.

The Cutler Majestic Theatre (219 Tremont Street, 617-824-8000, www.maj.org) resembles a stately bank more than it does a theater. Private interior tours are available for $5.

35. Chinatown

Nestled between the Financial District, Theater District, and South End is where you'll find Boston's colorful Chinatown.

Here the frame gets filled with accents of an Asian flair, among them the Chinatown Gate, or *paifang*, which marks the entrance to the neighborhood near the corner where Beach and Hudson streets meet. The gate is flanked by a pair of traditional *foo* dog sculptures. Adjacent in the opposite direction is the bamboo garden, the southernmost tip of the Kennedy Greenway.

Continue your Beach Street stroll to photo the likes of lively sidewalk market vendors, ornamental telephone booths, busy storefronts complete with colorful hanging lanterns, and an abundance of signs adorned in the authentic characters of the Chinese alphabet. For a Vietnamese, Chinese, or Thai-inspired lunch or dinner, Xinh Xinh (7 Beach Street, 617-422-0501) is the place to be. The Orange Line's Chinatown stop on the T proves most convenient.

36. South End: Victorian Row Houses

The South End neighborhood of Boston is predominately a residential one, home to a multicultural mix of Boston residents. The area is well known as Boston's "gayborhood," is a Boston Landmark District, and is listed on the National Register of Historic Places. And don't confuse the South End with South Boston (see chapter 8 for a fun photo stroll through "Southie").

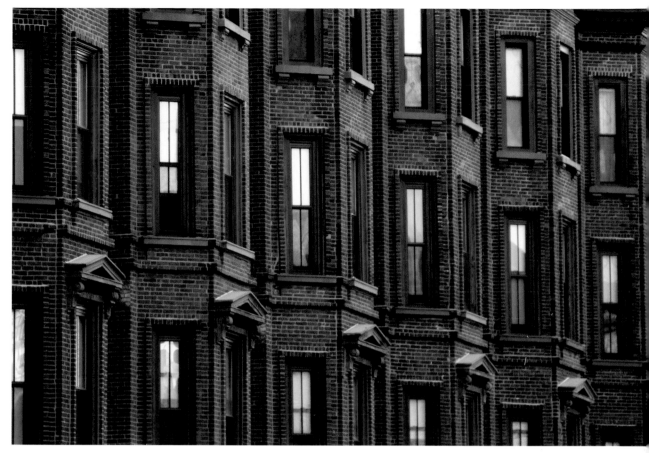

South End architecture

Renaissance Revival red-brick row houses reign in the South End part of town. Take a stroll along the likes of Tremont or Washington streets to capture more than a glimpse of these Victorian-era homes—you'll know them when you see them, as they are everywhere! Angle the shot just off center so that a perspective fills the frame.

And where there's a great neighborhood, there are lots of restaurants, too. Of note: Orinoco (477 Shawmut Avenue, 617-369-7075, www.orinocokitchen.com) for Latin American fusion fare, and Hamersley's Bistro (553 Tremont Street, 617-423-2700, www.hamersleysbistro.com) for slightly pricy but consistent New American cuisine.

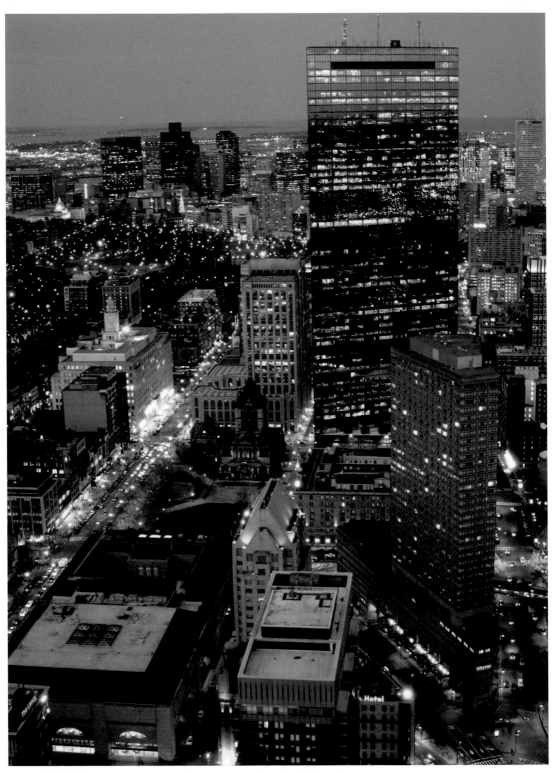

A view from the Skywalk Observatory atop the Prudential Building

V. Back Bay

General Description: The Back Bay is a tale of two neighborhoods: skyscrapers and office workers are abundant near Huntington Avenue and Boylston Street; Victorian residences line the streets a few blocks to the north.

Directions: The Back Bay is generally bordered by the Charles River to the north, Boston Public Garden to the east, Huntington Avenue to the south, and Kenmore Square to the west. The Green Line's Copley T stop or the Orange Line's Back Bay stop put you in the center of it all.

37. Commonwealth Avenue Mall/Back Bay Architecture

Commonwealth Avenue Mall in the Back Bay part of town connects Boston Common and the Public Garden to the rest of the Emerald Necklace. This boulevard-style bench-filled and tree-lined promenade makes practicing photo perspective easy.

Linden, Japanese pagoda, and elm trees line the leisurely route. When the trees are in full bloom you'll have to play with proper exposure levels and f-stops to compensate for light and shadow. In fall, colorful foliage abounds; while in winter, be the first to photograph the mall with a fresh blanket of snow. A number of monuments add the perfect foreground element to the frame as well.

The streets that surround the mall offer fine examples of the Back Bay's residential Victorian architecture. More examples can be found along Marlborough and Beacon streets,

Where: Boston's Back Bay is west of Boston Common and south of the Charles River. The rest of the Emerald Necklace parks are west and south of the Back Bay and Brookline.

Noted for: Upscale shopping, pools of reflection, busy city squares, and the tallest vantage point in all of Beantown

Best Time: Year-round

Exertion: Minimal–moderate for walking on level terrain

Parking: Street parking is tricky in this part of Boston. Metered street spaces can be hard to find, while the residential street spaces come with locals-only restrictions.

Sleeps and Eats: Fancy digs are provided by the Fairmont Copley Plaza Hotel (138 St. James Avenue, 617-267-5300, www.fairmont.com). Au Bon Pain offered a good sandwich, delicious soup, and an excellent cookie for less than $10. The service is no-nonsense brisk. Avoid it at the height of lunch hour if you can. Another good option is Café L'Aroma (85 Newbury Street, 617-412-4001, www.laromacafe.com) for coffee, biscotti, soup, and panini. The seasonal farmers' market at Copley Square also offers healthy snacks to go.

Public Restrooms: At many area coffee shops, cafés, and restaurants

Sites Included: Trinity Church, Copley Square, John Hancock Tower

Area Tip: Don't max out your credit cards at the high-end boutiques found along and near Newbury Street!

Commonwealth Avenue Mall

which run parallel just a couple of blocks north of the mall.

Commonwealth Avenue Mall runs along Commonwealth Avenue from Arlington Street at the border of Boston Public Garden to Kenmore Street near Kenmore Square.

38. Copley Square

Copley Square is a busy bustling urban public space with folks coming and going this way and that. The square provides the perfect foreground setting in which to capture the immediate Back Bay neighbors of the Boston Public Library, the Old South Church, Trinity

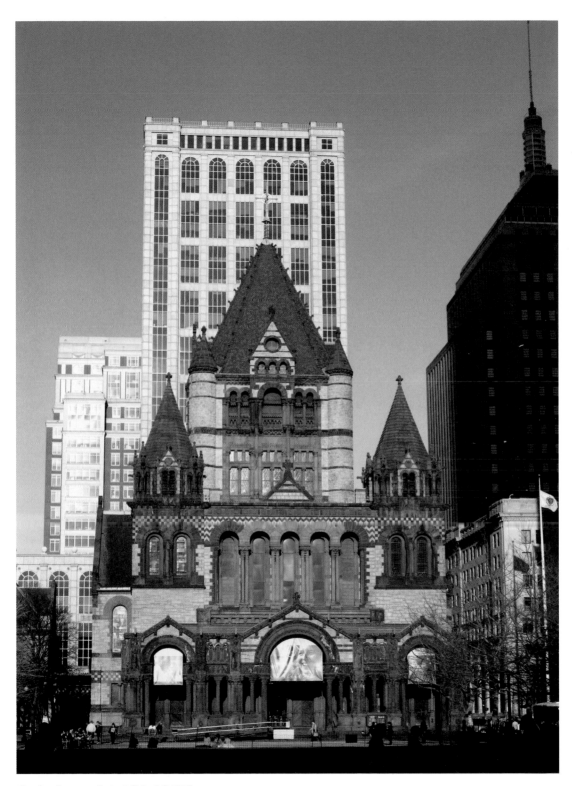

Copley Square shot at f10, 1/125th

Trinity Church shot at f10, 1/125th

Church, the John Hancock Tower, and the beaux-arts Fairmont Copley Plaza Hotel—the former Museum of Fine Arts. A seasonal farmers' market, open April through November, offers good things to eat and tasteful elements to the frame as well. Copley Square also provides the finish line for the annual Boston Marathon.

The place gets so busy at times, keep an eye on your gear here.

Copley Square is bordered at Boylston and Dartmouth streets and St. James Avenue.
Take the T: Green Line, Copley stop.

39. Area Houses of Worship

In busy Copley Square you'll find two of Boston's most beautiful churches to photograph.

In one corner is Trinity Church, H. H. Richardson's sumptuous Romanesque house of worship that dates from 1874. Among other shots you can capture a side glimpse of the church reflected in the glass façade of the neighboring John Hancock Tower. Diagonally opposite is the Old South Church, a Gothic revival gem.

Both boast active congregations so be considerate of parishioners. Both are also official National Historic Landmarks and listed on the National Register of Historic Places.

40. Boston Public Library

This main branch of the Boston Public Library provides a mix of Renaissance revival and beaux-arts styles where it faces Copley Square at the McKim Building front, and an oh-so-modernist approach along its Boylston Street, Johnson Building entrance.

There's plenty of room in Copley Square to set up a tripod. Passing pedestrians add to the frame but you'll also get a few parked cars in the shot. The building features plenty of architectural details worth exploring up close.

Photos are allowed inside the library, but there are a few restrictions. Flash is prohibited in

Old South Church

the reading rooms, and, while tripods are permitted, your equipment cannot block any passageways or interfere with users' visits. Permission is needed to film the public as well as the staff.

The sumptuous Bates Hall main reading room with its coffered arch ceiling should keep you busy for a while. The library offers free hourlong Art and Architecture tours daily (except Wednesdays and seasonal Sundays).

John Hancock Tower

Again, as with many buildings that border Copley Square, the library is a National Historic Landmark and is listed on the National Register of Historic Places.

At 700 Boylston Street.
Take the T: Green Line, Copley stop.
Call 617-536-5400.
www.bpl.org

41. John Hancock Tower

Now you see it, now you don't.

One of the more easily recognizable and prominent structures on Boston's skyline, the John Hancock Tower stands at 60 stories or 790 feet tall. It was opened in 1976.

Sometimes the tower appears as a jet black glass sculpture. And sometimes it just disappears into the clouds and sky. Adjacent Copley Square makes a good vantage point from which to capture New England's tallest structure.

Unfortunately, the 60th-floor observatory has been closed since just after September 11, 2001. A Boston bird's-eye view is best found at the nearby Prudential Building Skywalk Observatory, mentioned next.

At 200 Clarendon Street.
Take the T: Green Line, Copley stop.

42. Skywalk Observatory

From the Skywalk on the 50th floor of the Prudential Building you can easily spot Boston's most famous landmarks—the gold-domed State House, Bunker Hill Monument, JFK Library, Fenway Park, and the Citgo sign. On a clear day, you can see up to 80 miles away.

The visit comes with a panoramic view of Boston's metropolitan area as well as a few fun facts. You are shooting through thick panes of glass, though. Dusk sets the perfect mood and perfect views of the twinkling city lights in the downtown core below. Tripods are prohibited.

Atop the Pru, 800 Boylston Street.
Take the T: Green Line, Prudential stop;
 Orange Line, Back Bay stop.
Admission costs $12. Open daily (On
 occasion some portions may be closed
 for private events)
Call 617-859-0648.
www.topofthehub.net/skywalk

43. Christian Science Plaza

The Christian Science Plaza is the headquarters of the Christian Science Church, which was founded by Mary Baker Eddy in 1879. The space offers a few exquisite exterior photo ops.

The Mother Church, completed in 1894, and its extension, added just more than a decade later, respectively combine Romanesque and Italian Renaissance–style architecture. A good vantage point is from along Massachusetts Avenue. An evening shot provides excellent lighting.

The plaza's seasonal reflecting pool is an easy way to capture perspective. The shallow but immense pool—it measures almost twice as long as a football field, but half as wide—adds abstract photo reflection from nearby skyscrapers such as the Prudential Building. The neighboring 177 Huntington Avenue tower offers abstract minimalist appeal.

The onsite Mapparium is a unique place to visit, too. It holds a 3-story colored glass globe you walk into via a glass bridge. Unfortunately, photos are not allowed inside but it's well worth seeing. Free tours of the main church and grounds are offered daily except Mondays.

At 210 Massachusetts Avenue.
Take the T: Green Line, Prudential or
 Symphony stop.
www.christianscience.com

Christian Science Plaza

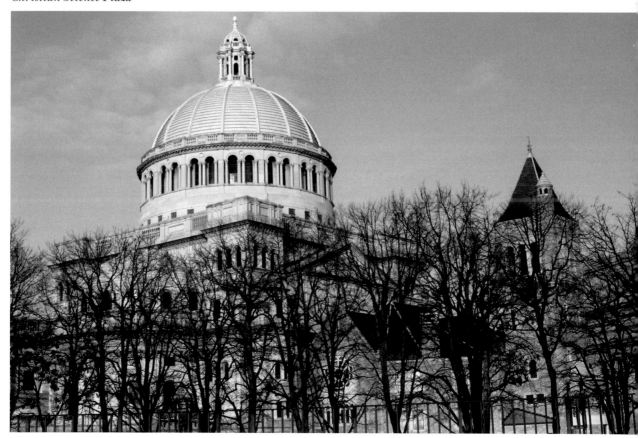

Fenway Park plaque shot at f5.6, 1/60th

VI. Kenmore/Fenway/Brookline/Emerald Necklace Extras

General Description: The Kenmore Square area is well known for being home to Boston's famous Citgo sign, while neighboring Fenway lays claim to the Boston Red Sox. Upscale Brookline and Longwood are home to a number of local universities and hospitals, most notably Harvard Medical School.

The Emerald Necklace was designed by landscape architect Frederick Law Olmsted. It strings together nine urban parklands. You've probably visited a number already, specifically Boston Common, the Public Garden, and Commonwealth Mall. Back Bay Fens is where the Emerald Necklace begins its journey south and west of downtown in a more natural setting, out of the Back Bay, Longwood, and Brookline neighborhoods. If you want to capture them all on your photographic bucket list, here's what to expect. Excellent online resources include the Emerald Necklace Conservancy at www.emeraldnecklace.org and the City of Boston Web site, Parks and Recreation section at www.cityofboston.gov. Also visit the Frederick Law Olmsted National Historic Site in nearby Brookline (99 Warren Street, 617-566-1689, www.nps.gov).

Directions: By car, take Commonwealth Avenue west from the Back Bay/downtown area. Kenmore Square is a stop on the T's Green Line.

44. Kenmore Square/Citgo Sign

Bostonians *love* their Citgo sign, an endearing beacon of home since 1940. The 60 by 60-foot neon sign is lit from dusk till dawn, so that's the best time to capture it.

This Kenmore Square icon has been featured in a number of movies including *Field of Dreams,* which is most appropriate as Fenway Park, home of the Boston Red Sox, is just a homerun away. The sign has also been the subject of documentaries and animated feature films, and was also highlighted in a *Life* magazine photo essay in the 1980s.

The landmark sign makes a great focal point in any number of perspective street shots along Beacon Street or Brookline and Commonwealth avenues.

The sign sits atop the building at 660
 Beacon Street.
Take the T: Green Line, Kenmore stop.

45. Fenway Park

Visiting baseball teams: Beware the Green Monster. Visiting photographers: Embrace the Green Monster.

No more faithful meaning rings true to the term *die-hard* when referencing the wicked loyal fans of the Boston Red Sox. That the team indeed broke their 86-year Curse of the Bambino and won the World Series in 2004 and again in 2007 means that current generations of Red Sox devotees can indeed rest as happy souls knowing their beloved team was crowned kings of baseball at least once—or twice—in their lifetime.

Photography is allowed at the game but commercial rights belong to Major League Baseball, so your shots are for personal use only. Camera bags are subject to search and only smaller bags are permitted.

That said, even if you don't have tickets, you can still capture America's favorite pastime in the form of local souvenir shops and colorful banners that dot the area along Yawkey Way. The area bustles come summertime with fans from all over New England and beyond, so people-watching shots are fun, too. Guided tours of the ballpark, which dates from 1912, are held throughout the year ($12 adults). Parking comes at a premium on game day, so it's best to take the T.

Fenway Park is bordered by Yawkey Way, Brookline Avenue, and Landsdowne, Ipswich, and Van Ness streets. Its main address is 4 Yawkey Way.

Where: West of Back Bay and downtown

Noted for: Green monsters, Red Sox, city gardens, fine art, and an urban landscaped masterpiece designed by Frederick Law Olmsted

Best Time: Year-round for the city scenes; late spring through fall for the parks

Exertion: Minimal–moderate for a lot of walking

Parking: Metered and free street parking isn't too hard to find. Pay lot at Fenway is busy on game day. For the Emerald Necklace, public lots are available at Olmsted Park, Arnold Arboretum, and Franklin Park. The Riverway and Jamaica Pond require parking on sometimes busy urban thoroughfares.

Eats: Fenway Franks on game day as well as any number of pub-style sports bar microbrewery eateries such as Game On! Fenway (82 Landsdowne Street, 617-351-7001), www.gameonboston.com) and Boston Beer Works (61 Brookline Avenue, 617-536-2337, www.beerworks.net). The Gardner Museum's Café offers lunch in an elegant setting.

Public Restrooms: At Fenway and the area's restaurants and museums. Also at Arnold Arboretum and Franklin Park & Zoo.

Sites Included: Fenway Park, Museum of Fine Arts, Citgo sign, Arnold Arboretum

Area Tip: Wear a New York Yankees shirt in this part of Boston—are you crazy?

Take the T: Green Line, Kenmore or
Fenway stop.
Call 617-267-1700.
www.mlb.com

46. Back Bay Fens

The next stop along the Emerald Necklace is
Back Bay Fens, which connects Common-
wealth Avenue Mall to the Riverway. Here, the
Emerald Necklace comes complete with pedes-
trian bridges, lush foliage, and the occasional

The endearing Citgo sign

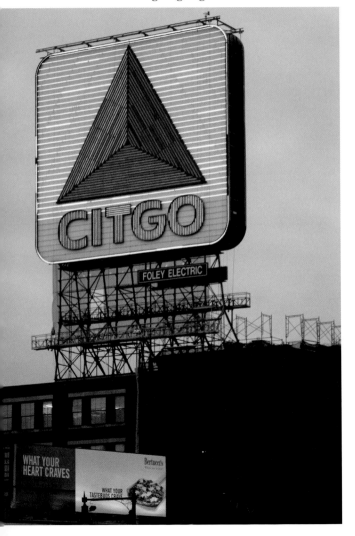

skyline view, all of which get playfully reflected
on a winding waterway called the Muddy
River, which resembles more a serene stream
than it does a mighty river.

The community gardens are fun to stroll
and photograph. The small plots are land-
scaped in a variety of ways—as personal as the
gardeners who tend them. You'll find it on the
western side of the Fens along Boylston Street
and Park Drive.

The small Kellecher Rose Garden attracts
photographers—a macro lens comes in handy
for colorful close-ups—as well as wedding par-
ties. The neighboring memorial, which pays
tribute to World War II, Korean, and Vietnam
vets, offers a fitting photo subject as well. Both
are accessible on the western side along Park
Drive or the eastern side along Fenway.

The back façade of the Museum of Fine
Arts, mentioned next, hugs a portion of the
Fens.

Take the T: Green Line, Fenway stop.

47. Museum of Fine Arts, Boston

You've picked a fine place to photograph.

Boston's Museum of Fine Arts provides in-
spirational photo opportunities both inside
and out.

The permanent collection includes an artis-
tic treasure trove of antiquities, textiles, and
contemporary art. But the must-see visit with
photography in mind is to the Herb Ritts
Gallery, a fairly new exhibition space devoted
entirely to the art of photography (it opened in
autumn 2008). The space highlights gems of
the MFA's vast permanent photo archives as
well as offering temporary exhibitions of ac-
claimed international photographers' work and
thematic photo explorations.

Another fine resource for photographers
can be found at the museum's Morse Study
Room of Prints, Drawings, and Photographs,
which offers a selection from the vast perma-

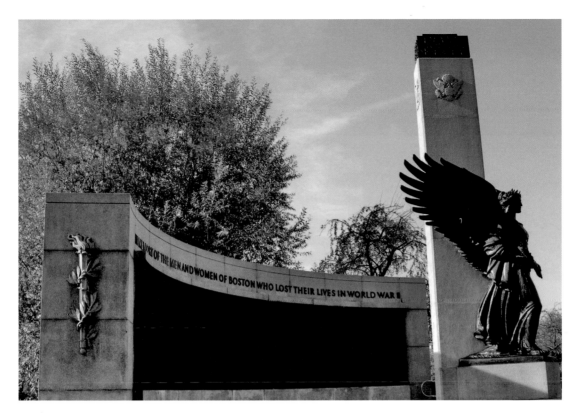

Back Bay Fens monument

nent collection on a rotating basis. The Morse Study Room is open by appointment only, Tuesday through Friday (617-369-3112).

Photography is allowed inside the museum as long as your photos are for personal use. (This applies to the museum's permanent collection only.) The use of tripods is prohibited, while flash is permitted with prior consent. Plenty of images are available for merchandise reprinting and educational purposes through the museum's Digital Imaging Resources department. Large bags are subject to search and must be checked.

The neoclassical-style building, complete with rotunda and 500-foot granite façade, as well as the refined landscaped grounds, both front and rear, is also worthy of a few shots. The Back Bay Fens is at the museum's doorstep.

At 465 Huntington Avenue.
Take the T: Green Line, Museum stop.
Admission costs $20 for adults.
 Open daily.
Call 617-267-9300.
www.mfa.org

48. Isabella Stewart Gardner Museum

The Gardner Museum offers an exquisite repository of fine, contemporary, and decorative arts. The collection was indeed founded by philanthropist Isabella Gardner.

The space also boasts an intriguing claim to fame. In 1990, thieves dressed as Boston police officers stole 13 works of art. They were never recovered. To this day the museum offers a $5 million reward for the return of the heisted goods.

Unfortunately, photography is prohibited throughout the museum (and that includes quick cell phone camera shots, too). Nonetheless, the space is gorgeous and still worth a visit, particularly to the Spanish cloister–style interior courtyard and garden with its superb annual horticultural displays of orchids and bromeliads in winter and the popular hanging nasturtiums every April. Also stick around for lunch at the Gardner Café any time of year.

What I would like to mention here is image rights and how some museums handle their art collections. Most museums indeed require permission for photos to be used commercially. The Gardner Museum requires requests for photographic materials to be made in writing. The point here: Check copyright requirements and restrictions at your favorite museum.

As mentioned in the sidebar, upscale Brookline is home to a number of local universities and hospitals. Architecturally worthy of photographing nearby is the Harvard Medical School building with its green quad foreground at the corner of Longwood Avenue and Avenue Louis Pasteur.

The Gardner Museum is at 280 Fenway.
 Take the T: Green Line, Museum stop.
Admission costs $12 for adults (free forever if your first name is Isabella!). Closed Mondays.
Call 617-566-1401.
www.gardnermuseum.org

49. The Riverway/Olmsted Park
The Riverway may be your quickest walk in the Emerald Necklace woods.

More of a connector park from Back Bay Fens to the north and Olmsted Park to the south, Riverway nonetheless provides urban respite and photo ops in the form of the Muddy River, a stone gazebo at the Chapel

Appeal to the Great Spirit, *by Cyrus Dallin, graces the MFA's south entrance*

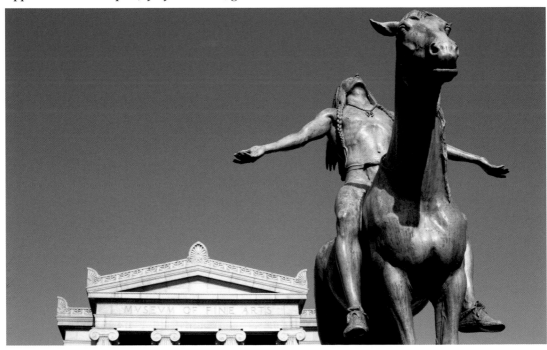

Street Bridge, and one of Olmsted's signature stone bridges. The Riverway is not just the name of the park but of the thoroughfare that runs along its eastern side. Access is also available by taking the Green Line to the Riverway stop.

Venturing south, Emerald Necklace landscape architect Frederick Law Olmsted gets a park named after him, and rightly so.

Olmsted Park features a tranquil walk in the woods complete with the centerpiece Leverett and Wards ponds as the photographic focal point. Any number of hiking trails will get you there. The occasional Wards Pond fisherman silhouette adds to the frame, as will local bird and turtle species and a wildflower meadow.

Olmsted Park is nestled between Pond Avenue and the Jamaicaway. Parking is located off Pond Avenue near Leverett Pond in the northern sector of the park.

50. Jamaica Pond

Compared to its Olmsted Park contemporaries just mentioned, Jamaica Pond is practically an ocean.

The photo to capture here is the pond itself, and each season brings with it unique attributes to the frame. In summer, make your way to the boathouse to add sailboats and nautical themes to this mini seaside adventure. A fall foliage blaze of color circumnavigates the park by early October. Passersby, bikers, and joggers add foreground silhouettes any time of year. A puffy cumulus cloud literally adds reflective pause to the shot. And some of the best sunsets in town can be explored at Jamaica Pond. The estates that encircle the pond are pretty impressive, too.

Jamaica Pond is just south of Olmsted Park and is bordered by the Jamaicaway and Pond Street (the boathouse is at this intersection) on its eastern shore, and Perkins Street and Francis Parkman Drive on the western side.

Olmsted Park

51. Larz Anderson Auto Museum

From the beauty of a curved chrome bumper to the good looks of a front-end grill, the Larz Anderson Auto Museum provides a variety of vintage and classic cars as the subject of note. Some two dozen cars are always on display, and on any given weekend, special events bring visitors who arrive in their own classic cars. The collection was once owned by Larz and Isabel Anderson, prominent folks in their day.

Photography is allowed inside, as is flash—perhaps reduce the glare from all that shiny chrome with a diffuser filter. Tripods are also

Jamaica Pond

allowed on certain days. The carriage house, which houses the collection, also offers a fine photo op.

At 15 Newton Street, Brookline.
Open Tuesday through Sunday; winter hours Friday through Sunday.
Admission costs about $10.
Call 617-522-6547.
www.larzanderson.org

52. Arnold Arboretum

If you only have time to photograph one Emerald Necklace gem, place the magnificent Arnold Arboretum to the top of the list. A visit is highly recommended through all four seasons.

This joint venture between the City of Boston and Harvard University is a frequent respite for all Bostonians. Nature photographers have plenty of year-round options to explore here, among them spring cherry blossoms, rhododendron and azalea blooms, sultry late spring magnolias, lush summer hydrangea, a fall foliage extravaganza, and a winter wonderland best accompanied by a fresh blanket of snow. A bonus: The place smells great, particularly the conifer/pines section.

Most paved paths lead to four mini mountains contained within the park boundaries—Hemlock, Bussey, Peters, and Weld hills—the highest of which measures in at 240 feet tall. Each is about a 20-minute leisurely stroll uphill from any parking area and the payoff is spectacular—just look at that skyline view of Boston!

Arnold Arboretum's Hunnewell Visitor Center is accessible at 125 Arborway.
Enter the arboretum at Arborway, Walter, Centre, and South streets.

Admission is free. Hours are daily from
sunrise to sunset.

Take the T: Orange Line, Forest Hills stop.

Call 617-524-1718 (visitor center).

53. Franklin Park Zoo

Wild, I tell you! Franklin Park Zoo is one of the
nation's oldest public zoos. Here you'll find
wildlife highlighted in a number of exhibits, in-
cluding Tropical Forest, full of gorillas, hip-
popotami, and vultures; Outback Trail, home
to the likes of kangaroos and cockatoos; and
Butterfly Landing, a seasonal exhibit where
butterflies fly free.

Cameras are permitted onsite. Tripods are
prohibited.

The adjacent Franklin Park offers a more
open green space, baseball and softball dia-
monds, and a golf course.

Both park and zoo are the last jewels of the
Emerald Necklace.

At One Franklin Park Road in Dorchester.
The zoo is open daily.

Take the T: There are a number of public
transportation options, including taking
the Orange Line or the commuter rail to
Forest Hills station, and then the number
16 bus to Franklin Park Zoo.

Admission costs about $14 for adults.
Parking is free.

Call 617-541-5466.

www.zoonewengland.org

Arnold Arboretum

A pleasant day at Pleasure Bay

VII. South Boston/Convention District/South Boston Waterfront

General Description: Say you're from "Southie," and the locals know you're proud to be from this well-known working-class Irish neighborhood.

Directions: The Silver Line gets you to the Convention Center and waterfront area. The Red Line stops Broadway, Andrew, and JFK/UMass service the area as well. The number 11 bus from South Station gets you near Pleasure Bay.

54. South Boston Waterfront

The South Boston waterfront combines Boston's rich seafaring heritage and modern city attributes in a single frame.

Near Boston Fish Pier along Seaport Boulevard, fishing trawlers line up dockside waiting to depart for the day's catch. This fun nautical photo op's got it all—perspective, shape, color—all readily supplied by these hearty, weathered sea craft. A dramatic sunset adds to the atmosphere of the frame facing seaward, whereas changing your angle toward the busy skyline juxtaposes these old-world traditions with a bustling urban setting.

The nearby World Trade Center (200 Seaport Boulevard) offers geometric perspective as colorful rows of flags of all nations line the lot. Then walk a few blocks south to find the fairly new Boston Convention and Exhibition

Where: South and east of the downtown core/Financial District

Noted for: The Irish Riviera, fishing fleets, seaport-style architecture and scenery, the annual Saint Paddy's Day Parade

Best Time: Year-round, particularly Saint Patrick's Day

Exertion: Minimal for walking but there is some ground to cover

Parking: Parking is tricky in residential Southie. The Convention Center area is less busy on weekends; metered street parking is available. Boston Design Center offers a pay lot.

Sleeps and Eats and Drinks: Area lodging includes the Seaport Hotel, the Westin Waterfront, and the Renaissance Boston. Excellent seafood can be savored at Legal Test Kitchen, a.k.a. LTK Bar and Kitchen (225 Northern Avenue, 617-330-7430, www.ltkbarandkitchen.com). And there's no better place to be than in Southie on Saint Patrick's Day for the parade, usually the Sunday prior to the holiday. Toast the day away with sociable locals and maybe some Irish immigrants at two of the friendliest neighborhood bars in town: Clock Tavern (342 West Broadway, 617-269-9449) where Irish lads/loyal patrons Steven, Sean, and Benny, with their tall tales and unmistakable accents, are sure to put a smile on your face; and L Street Tavern (658A East 8th Street, 617-268-4335), whose interior appeared in *Good Will Hunting*. A libation fun fact: Absolut Boston Vodka, flavored with black tea and elderflower, comes in a lovely shade of light green!

Public Restrooms: At the Convention Center

Sites Included: Boston Design Center, Pleasure Bay, Institute of Contemporary Art

Area Tip: If authentic seafaring photo ops are your favorites, then schedule some time for the South Boston waterfront.

Center. There's an elevated pedestrian walk-way that runs from the Convention Center's front plaza to the Silver Line T station. Here, you'll have ample room to set up a tripod to capture a slice of the Boston skyline—a zoom lens helps shoot past the parking lot.

An even better shot can be had when facing west from the Sleeper Street and Seaport Boulevard intersection. A short bridge and row of streetlights provides a wonderful line of perspective while the glass-canyon Financial District sets the background skyline scene.

55. Institute of Contemporary Art
Eclectic artistic inspiration reigns inside and out at Boston's Institute of Contemporary Art. A visit is highly recommended.

The exterior shot of its signature glass cube, which hovers above the waterfront, is best cap-tured at dawn or dusk to create a fun architectural exploration of color, light, and shape. Once inside, the inspiration comes from the contemporary art and photography showcased in its permanent and temporary galleries.

That said, shots are allowed in the interior public areas and outside, but prohibited in the galleries unless the ICA gives consent beforehand, says their Web site. In addition, photos must only be for noncommercial personal use.

At 100 Northern Avenue.

Admission costs about $15 for adults; free from 5 to 9 PM. Thursday evenings. Closed Mondays (except for most holiday Mondays).

Take the T: Silver Waterfront Line, World Trade Center or Courthouse stop.

Call 617-478-3100.

www.icaboston.org

The Financial District from the South Boston waterfront

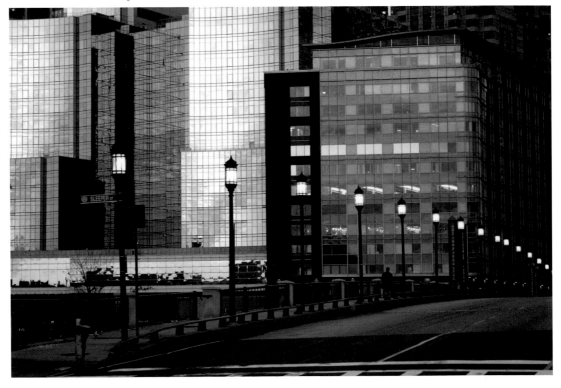

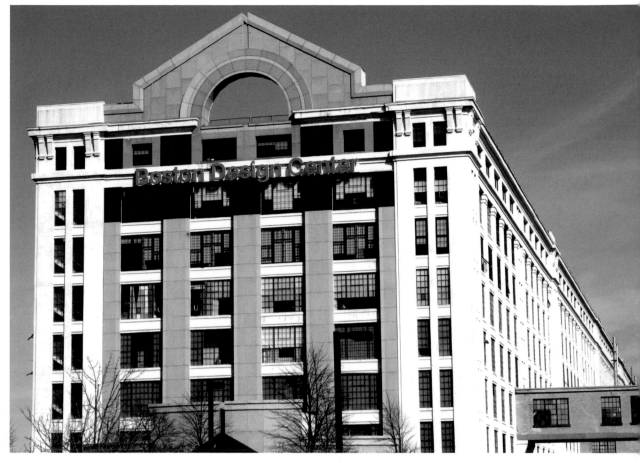

Boston Design Center shot at f16, 1/500th

56. Boston Design Center

Need to practice perspective? Just make your way to the Boston Design Center, the BDC. A first glance at the building will guarantee an audible "wow." I know I said it.

There must be hundreds if not thousands of windows on this 1,638-foot-long, 8-story-tall warehouse. It goes on forever and ever and it will fill up the frame as far as the eye can see.

Once part of the area's army base, the structure dates from 1918 but has been home to high-end interior design and architect professionals since the 1980s. You can visit the furniture showrooms but you can't buy as it's a design industry wholesale operation. For more info on the building, read the article "Transition in Time" by Charles Spada in the summer 2003 issue of *Cybele* magazine, which is available online in the Design Inspiration section of the BDC's Web site.

Added photo op: Visiting cruise ships dock just next door at the Black Falcon Terminal.

At One Design Center Place/Dry Dock Avenue.

Take the T: Silver Line Waterfront, Boston Design Center stop.

Call 617-449-5501.

www.bostondesign.com

Dorchester Heights Monument

57. Fort Point Channel

West of the Convention Center you'll find Fort Point Channel, an active maritime waterway that separates South Boston from downtown.

A small park along Dorchester Avenue just north of Gillette Park (as in Gillette, the shaving products manufacturer—that's their building next door) offers a roomy enough vantage point from which to include parts of the downtown skyline and neighboring railway lines into the industrial-style architectural photo op. Remnants of the Old Colony Railroad Bridge now serve as public art and a colorful burnt red foreground element to the shot. It's also a great place to practice and play with image reflections that the still waters of the channel provide.

The park is part of the Fort Point Channel section of the Boston HarborWalk (www.bostonharborwalk.com; Also see entry 17). The channel is also where the infamous Boston Tea Party took place. A museum devoted to the event, the Boston Tea Party Ships and Museum (304 Congress Street, 617-338-1773, www.bostonteapartyship.com) explores the event but it was closed for renovation at press time. A number of bridges traverse the channel as well (see entry 54).

58. South Boston Architecture

Unique townhouses and single-family homes line the streets of South Boston, which is well known for its Irish working-class ties. The area is bordered south of the South Boston Waterfront, east of Highway I-93, north of William J. Day Boulevard, which hugs the Old Harbor waterfront, and west of Pleasant Bay.

While on your way to Pleasant Bay (mentioned next), venture to the likes of the alphabetized roads of G, H, I, J, K, L, M, and N streets for a glimpse of Southie-style architecture.

The Old Harbor waterfront features seaside views and there's always a jogging Southie resident or two to add to the foreground. Across the harbor, that is indeed the JFK Library and Museum (see entry 60).

The Dorchester Heights Monument, operated by the National Park Service, is another fine South Boston photo op. The monument, made of Georgia white marble, features an octagonal cupola and weather vane worthy of a

close-up. You can also easily squeeze in the entire monument and park land into the establishing shot. It's located at Thomas Park in the Telegraph Hill part of town. The elevated hill on which the monument stands combines a glimpse of local architecture in the foreground and the Boston skyline in the background.

59. Pleasure Bay/Fort Independence

Pleasure Bay offers lovely harborside scenery. The park space features a milelong path that surrounds the bay and there are always a few folks walking about, which create simple silhouettes. Here, sample a spectacular morning sunrise or stick around for a dramatic sunset. Located on the grounds, Fort Inde-

pendence adds a bit of military might to the frame. And don't pay any attention to the low-flying aircraft—they're on their way to Logan Airport.

There is a particular photo tip I'd like to share here. In fact, it's one of my worst habits when photographing in the field. Perhaps you do it, too. I did it at Pleasure Bay.

Often when strolling about with camera in hand, I'll take a shot of my main subject—of course, always in a high-res setting. But to save room on my flash card, I occasionally switch the setting to low-res to capture the likes of street signs, outdoor maps, and monument plaques to use as reference later on.

My problem is that I sometimes forget

Pleasure Bay shot at f 7.1, 1/125th

to switch the camera back to the higher-res setting. I suffered the consequences when capturing a great shot of a fishing boat complete with a perspective of pier pylons and action in the form of low-flying seagulls. By the time I made it to the Pleasant Bay parking lot, I realized what I had done. I rushed back to the dock only to find my ship had set sail.

Indeed, it was the shot that got away.

60. John F. Kennedy Presidential Library and Museum

This gorgeous waterfront building provides an exterior study of geometry, clean lines, and simplicity, while the interior houses plenty of treasures as well, specifically the massive collection of archival photographs that document JFK's storybook life and presidency.

The sky strategically plays an important part in this shot as a vibrant blue background accentuates the building's white façade and black-glass lobby cube. At dusk, dramatic sunset leaves the glass lobby visible from the inside out.

At Columbia Point adjacent to the University of Massachusetts.

Take the T: Red Line to JFK/UMASS station. Transfer to the free JFK shuttle bus to the library.

Admission costs about $12. Open daily.

Call 866-JFK-1960.

www.jfklibrary.org

South Boston waterfront

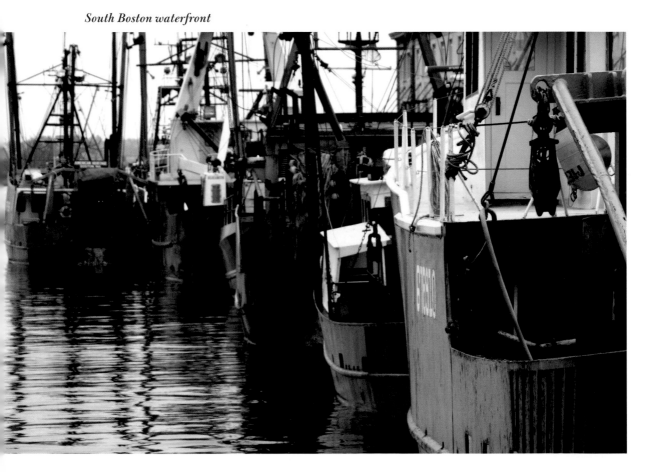

John F. Kennedy Presidential Library and Museum

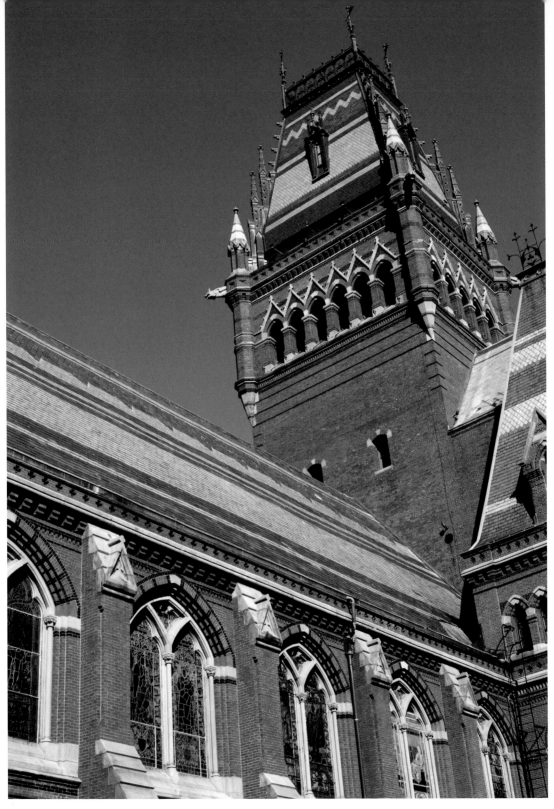

Memorial Hall of Harvard University

VIII. Cambridge

General Description: Schools rule in this part of town, particularly the campuses of Harvard University and Massachusetts Institute of Technology. An excellent local resource is the Cambridge Office of Tourism Web site at www.cambridge-usa.org.

Directions: The T provides service to Harvard University at the Harvard Square stop; MIT is best serviced by the Kendall Square stop, both accessed on MBTA's Red Line.

61. Harvard University/Square/Yard

There are many Harvard University photo ops in the immediate Harvard Square vicinity if traveling by subway.

Harvard Square proper adds a bustling slice of student life, complete with a famous newspaper kiosk and competitive chess players.

The surrounding campus boasts numerous halls and academic complexes—most meticulously cared for—no peeling paint on these colorful buildings.

Harvard Yard, with its crisscross pattern of pathways, offers the perfect geometric abstract foreground in which to capture Memorial Church as a focal point. That said, most of the other Harvard Yard buildings are college dorms, so be considerate of the students.

Venture a short walk south along John F. Kennedy Street to the banks of Charles River to find one of Boston's most iconic shots—intrepid Ivy League rowing crews preparing for the big race. It's easy to squeeze the Weld Boathouse, a nearby campus building tower, and some steadfast rowers into the same frame when photographing the shot from the neighboring Anderson Memorial Bridge.

And you may just spot a celebrity or two:

Where: North of the Charles River

Noted for: Young scholars, intrepid rowers, Hasty Pudding celebrations

Best Time: Year-round

Exertion: Minimal–moderate for walking and driving

Parking: Pahk the cah in Hahvad Yahd (I kid!). Metered street parking is available if the parking fairy is on your side that day. A parking garage is available at the Red Line's Alewife terminal at Alewife Brook Parkway and Cambridge Park Drive ($7 daily).

Sleeps and Eats: Harvard Square Hotel (110 Mount Auburn Street, 617-864-5200, www.hotelsinharvardsquare.com) and the Charles Hotel (1 Bennett Street, 617-864-1200, www.charleshotel.com) are both centrally located in or near Harvard Square. Hungry Mother (233 Cardinal Medeiros Avenue, 617-499-0090, www.hungrymothercambridge.com) offers sumptuous dinner-only Southern fare near MIT.

Public Restrooms: At area museums, coffee shops, and restaurants

Sites Included: Harvard University, Stata Center, Longfellow House, Boston skyline views

Area Tip: Be considerate of the many students who temporarily call Cambridge home.

The annual Hasty Pudding Parade presented by Hasty Pudding Theatricals pays homage to an entertainer man and woman of the year. Big-name Hollywood celebs win the illustrious prize annually. Good sports that they are, the celebs almost always attend the festivities in their honor, which includes a parade complete with men in drag that runs right through Harvard Square every winter.

Memorial Hall interior shot at f5, 1/100th

62. Cambridge Museums of Note

Documentation and fine art photography are best explored at a number of Cambridge-area museums.

While separate entities with varying collections, these Harvard University–run museums come with much of the same photo restrictions: Photography for personal use is allowed inside the galleries; commercial photography requires written permission; flash and tripods are prohibited. The T Red Line, Harvard Square stop gets you close.

Located just past Harvard Yard, Harvard Museum of Natural History (26 Oxford Street, 617-495-3045, www.hmnh.harvard.edu, $9 adults, open daily) houses the vast natural history collection of Harvard University. The space abounds with habitat dioramas, natural history specimens, and a colorful minerals and gems collection.

The nearby Peabody Museum of Archaeology and Ethnography (11 Divinity Avenue, 617-496-1027, www.peabody.harvard.edu, $9 adults, open daily) contains an admirable assortment of cultural artifacts and an immense archival photography collection—it numbers some 500,000 images in all, everything from daguerreotypes to slides. The collection thoroughly documents a variety of indigenous world cultures and is highlighted in any given exhibition as well as accessed online.

The Fogg Museum (485 Broadway, 617-495-9400, www.harvardartmuseum.org, $9 adults, open daily) offers an immense photography collection with more than 20,000 pieces showcasing fine art and American professional photographers.

63. Memorial Hall

The Memorial Hall auditorium/Lowell Hall classroom complex is where the stage gets set for Harvard University theater productions. I must admit, I almost got into a fender bender

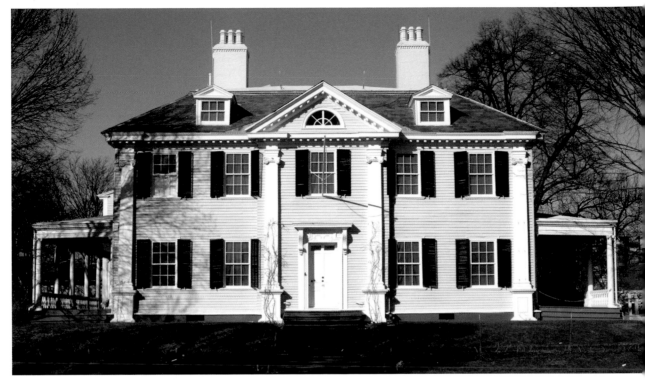

Longfellow National Historic Site, shot at f8, 1/500th

while passing Memorial Hall, a National Historic Landmark, when making a wrong turn en route to the Longfellow House mentioned next—the hall's High Victorian gothic tower really did distract me from my driving—quite beautifully impressive.

Casual pub fare can be had onsite at the Queen's Head Pub.

At 45 Quincy Street.
Call 617-496-4595 or 617-496-2222 (box office).
Visit www.fas.harvard.edu/memhall.

64. Longfellow National Historic Site

Run by the National Park Service, the Longfellow House offers a prime example of the street's gorgeous Georgian-style mansions. It was indeed the residence of American poet Henry Wadsworth Longfellow. George Wash-

ington used the house as command headquarters during the Revolutionary War.

Although tours are seasonal, you can capture an exterior shot any time of year. In addition, the occasional costume-clad reenactor adds a lighthearted animated moment to the frame. It's about a 10-minute walk from the Harvard Square T stop.

At 105 Brattle Street.
Admission costs $3 for adults.
Call 617-876-4491.
Visit www.nps.gov/long.

65. MIT

Of all the words I could use to describe the MIT campus in Cambridge, three come to mind immediately: the Stata Center.

And three more: Don't miss it.

Opened in 2004, the Ray and Maria Stata

MIT's Stata Center

Center is an academic complex of the Massachusetts Institute of Technology. It was designed by acclaimed architect Frank Gehry.

With its nonsensical, almost haphazard design, the building evokes a storybook pop-up on the verge of imminent collapse (think Frank's crumbled pieces of paper as design inspiration). The playful geometric patterns are best captured from the rear plaza. You could spend the day photographing this one.

Also of note for photography on campus is the multicolored, multiwindowed geometrically inspiring Simmons Hall dormitory building (229 Vassar Street), which was once the subject of an intriguing Canadian Centre for Architecture exhibition called "Inside the Sponge"; and the cylindrical MIT Chapel (Building W15, 48 Massachusetts Avenue), which comes complete with moat. Stick around for some artistic design inspiration at the MIT Museum (Building N51, 265 Massachusetts Avenue, 617-253-4444). Campus tours are held weekdays at 11 AM and 3 PM. Self-guided tour maps are also available at the information center.

At 77 Massachusetts Avenue, Cambridge (Information Center).
The Stata Center, Building 32, is at 32 Vassar Street.

Take the T: Red Line, Kendall Square stop. Call 617-253-4795 (general information). Visit web.mit.edu.

66. Charles River Skyline Views/Longfellow Bridge

While you're at the MIT campus, make your way to the Charles River water's edge for a great Boston skyline view. In season, April through October, the shot will include the city's iconic sailboats that dot the waterway—Community Boating's marina is located less than a mile away along the Esplanade in Boston's Beacon Hill neighborhood shoreline just across the river (see entry 19).

Memorial Drive runs along the northern banks of the Charles River and MIT's Building 51 Wood Sailing Pavilion/Pierce Boathouse (134 Memorial Drive) offers a small marina, dock, and limited parking. The Charles River bike path adds a cyclist to the foreground of the shot, as does the Longfellow Bridge. That said, save this one for dusk as you face the sun for most of the day.

Charles River and skyline view from Cambridge near MIT

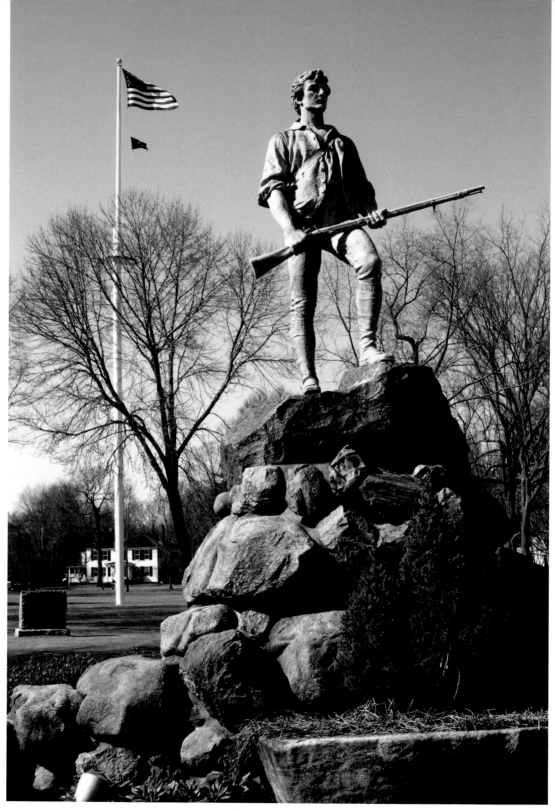

Lexington Common's Minute Man statue

IX. Points North

Salem area

General Description: Not just a suburb of Boston, the port city of Salem put itself on the map with the witch trials of the late 1600s—and the town has never looked back. Salem is well known the world over for its Halloween fun.

Directions: By car, travel north from Boston on Route 1A and then east along Route 107 into Salem. By commuter rail from Boston's North Station, take the Newburyport or Rockport line to Salem station. The very reasonable round-trip fare costs about $11. Downtown Salem is about a 10-minute walk from the train station. Boston's Best Cruises and CityView Trolley Tours offer access by boat and bus, respectively. Check their listings in the back of the book under "Suggested Guided Tours."

67. Salem: Streets and Strolls

Salem was first settled as a seaport in 1626. Much of the local architecture offers colonial history, often a plaque of who once lived there, and windows, lots of windows—I've never seen so many windows on houses in all my life. While you may have to sift through some tacky tourist spots, there are some wonderful photo ops of note.

Maritime flair is easily added to the frame at any number of Salem Harbor stops, including the Salem Maritime National Historic Site at Derby Wharf (174 Derby Street, 978-740-1660, www.nps.org). Run by the National Park Service, the site is an excellent way to start your Salem visit and offers a museum space, historical buildings, ranger-led and self-guided tours of the neighborhood, access to the tall ship *Friendship,* and hosts the annual Maritime Festival every summer.

Where: About 20 miles north of Boston

Noted for: The infamous Salem witch trials of 1692

Best Time: Autumn (for the Halloween atmosphere)

Exertion: Moderate—for lots of walking

Parking: Available year-round but very restricted in October

Sleeps and Eats: The Hawthorne Hotel (18 Washington Square, 978-744-4080, www.hawthornehotel.com) is *the* place to stay in town—but book your Halloween vacation up to a year in advance. There are some excellent restaurants in Salem. Sample serious steaks in a lively bistro atmosphere at the Lyceum (43 Church Street, 978-745-7665, www.thelyceum.com). For casual burgers and busy sports pub fun try Tavern in the Square (189 Washington Street, 978-740-2337, www.taverninthesquare.com). Very good casual Thai fare can be had at Bangkok Paradise (90 Washington Square, 978-825-9202, (www.bangkokparadise.com).

Public Restrooms: At dozens of area restaurants and museums.

Sites Included: Downtown Salem, Salem Maritime National Historic Site, Salem Willows, Peabody Essex Museum

Area Tip: A day-trip (or two) to Salem is highly recommended.

The McIntire Historic District offers Federalist-style architecture aplenty. Venture east of the Peabody Essex Museum and stroll along the likes of Chestnut, Essex, Broad and Warren streets.

Across from Salem Common, the Salem Witch Museum (19 North Washington Square, 978-744-1692, www.salemwitchmuseum.com)

House of the Seven Gables

is all aglow in hues of crimson and purple every Halloween. A number of centuries-old cemeteries, one on Charter Street and one across from the commuter rail station on Bridge Street, add a bit of appropriate local atmosphere to the frame.

The House of the Seven Gables (115 Derby Street, 978-744-0991, www.7gables.org) offers a perfect example of colonial architecture—the wooden mansion dates from 1668. The museum space offers period artifacts and a collection of some 500 vintage photographs.

68. Salem: Halloween

In a word: Boo.

Ghosts and goblins, warlocks and witches (some real ones at that) highlight a visit to Salem any time of year. But wait till you see the place around Halloween.

Salem's streets bustle with activity every October with visitors who come from near and far to celebrate Halloween in this part of the world. And there's no need to wait until Halloween night, as folks come dressed for the part a week or more in advance.

Photo ops of note include costumed characters, an annual carnival, candlelit processions, guided walking tours, and good old fun in the form of people-watching at its best. If any apparitions mysteriously appear in your photos, don't blame me.

To help plan your Salem Halloween journey into darkness visit Salem Haunted Happenings at www.hauntedhappenings.com, Salem City Guide at www.salemweb.com, the Salem Witches' Halloween Ball at www.festivalof thedead.com, and Destination Salem at www .salem.org.

69. Salem: Willows Park

Although Halloween takes center stage in downtown Salem come fall, Salem Willows Park enjoys dibs on the town's fun every summer.

This seasonal busy spot offers a few amusement park rides, arcade folly, and a carousel.

The place holds a special place in the hearts of local kids of all ages. The adjoining beach park offers a picturesque photo visit any other time of year with seaside scenery, cherry blossoms in spring, and grand 200-year-old white willow trees, of course, for which the park is named. Summer parking comes at a premium.

At 167 Fort Avenue.
Call 978-745-0251.
www.salemwillowspark.com

70. Salem: Peabody Essex Museum

The Peabody Essex Museum is one of New England's premier art resources, boasting an impressive collection of maritime, American, Asian, and African art. Its inspiring photogra-phy collection—from daguerreotypes to digital prints—numbers near 1 million photos. The collection is often highlighted in a variety of exhibitions on any given day.

Don't miss the centerpiece Yin Yu Tang, the Huang family's ancestral home, an actual 200-year-old 16-bedroom Chinese home that was reassembled at the PEM. Unfortunately, photography is prohibited inside Yin Yu Tang but is allowed in the permanent collections galleries—but only if the photos are for personal, noncommercial use. Flash and tripods are prohibited. Large bags and knapsacks must be checked. The open, airy lobby is worth a quick shot for its soaring sculptural glass ceiling and architectural details.

Salem streets and strolls

This is one of Salem's must-see visits.

At 161 Essex Street, East India Square.
Admission costs about $15 for adults.
Closed Mondays.
Call 978-745-9500.
www.pem.org

71. Marblehead

For picturesque Atlantic oceanside scenery, it doesn't get more New England than this.

I included Marblehead more as a stop if you're traveling by car than by tour bus or commuter rail—this stop is best accessed with your own transportation.

But quaint, you say? Make your way to the Ocean Avenue causeway bridge, where a shot facing west offers a crisp blue bay dotted with any number of boats occupying the foreground while colorful fall foliage, a dramatic sunset, cliffside houses, and church steeples fill out the background frame.

Continue along Ocean Avenue to the Marblehead Neck peninsula to find the Marblehead Neck Wildlife Sanctuary for bird-watching photographers and Chandler Hovey Park, home to Marblehead Light Tower, maybe not the most photogenic of lighthouses, but it's picturesque nonetheless.

The town proper offers its own Main Street charm and photo ops as well along Darling Street.

From Boston take Route 1A north to Route 107 north into Lynn and then Route 129 north into Marblehead.

Marblehead view

Lexington Historical Society

Lexington/Lincoln/Concord

General Description: These Boston suburbs are full of Revolutionary-era remnants.

Directions: From Cambridge, head west along Massachusetts Route 2, the Cambridge and Concord Turnpike.

72. DeCordova Museum and Sculpture Park

Channel the inner contemporary artist in you at the DeCordova Museum and Sculpture Park.

The whimsical 35-acre sculpture park features some 75 works of fanciful contemporary outdoor art. That said, works do fall under copyright, so your shots are for personal noncommercial use only unless you secure permission. Most of the works are permanent, but the space rotates borrowed art on an annual basis.

I love Rick Brown's *Butterfly Effect,* which looks as if some goddess from the heavens

Where: A 25-minute drive northwest of Cambridge

Noted for: Revolutionary battles, midnight rides, and literary hallowed ground

Best Time: Spring through fall

Exertion: Minimal for mostly driving; moderate if you're walking the entire 5-mile-long Battle Road Trail

Parking: At area sites

Eats: Cheese Shop of Concord (29 Walden Street, Concord; 978-369-5778; www.concordcheeseshop.com) for cheese, please. Gourmet sandwiches and delicacies, too.

Public Restrooms: At major sites mentioned.

Sites Included: Minute Man National Historical Park, Walden Pond

Area Tip: Avoid the drive out of Boston at rush hour. And don't confuse Minute Man National Historic Park with Minuteman Missile National Historic Site (in South Dakota)—very different ammunition!

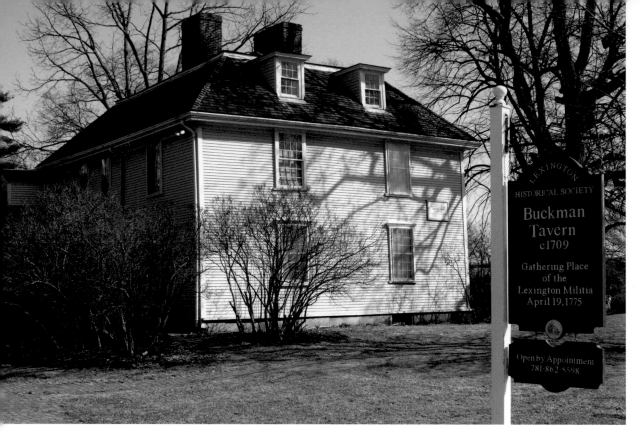

The Buckman Tavern in Lexington

misplaced her string of pearls. Artist Breon Dunigan's bronze *Guardian, Hearing Trumpet,* and *Torsion* are whimsical abstracts—complete with feet. And Joseph Wheelright's *Listening Stone* literally puts an ear to the ground, with a large granite head eavesdropping in on the rhythms of the Earth.

> At 51 Sandy Pond Road, Lincoln.
> The MBTA commuter rail Fitchburg Line, Lincoln station is less than 2 miles away.
> Admission costs $12 for adults. The sculpture park is open daily from dawn to dusk. The museum is closed Mondays. (Admission fees to the sculpture park are charged only during the museum's opening hours).
> Call 781-259-8355.
> www.decordova.org

73. Walden Pond State Reservation

The writers theme continues at Walden Pond State Reservation, where Henry David Thoreau was so inspired. Hopefully, you'll be inspired, too.

Pond Path encircles Walden Pond for a leisurely stroll and a variety of angles, particularly away from the busy summer beach throngs. Thoreau's original cabin still stands, located near Thoreau's Cove.

Fall may be the best time to visit, as local foliage offers a pretty spectacular show and a bonus in the lack of summer crowds—the place and the parking area get pretty packed on sultry summer days.

> The Visitors Center is at 915 Walden Street, Concord. Take Rte. 2 West and Rte. 126 South.

Parking costs $5. You can also take the commuter rail to the Concord station and walk to the park.
Call 978-369-3254.
www.mass.gov/dcr/parks/walden

74. Lexington

Historical colonial-era houses abound in Lexington town proper, just east of the Minute Man National Historic Park. The Lexington Historical Society headquarters on Massachusetts Avenue in the center of town (781-862-1703, www.lexingtonhistory.com) makes for a more than decent historical photo and is a good place to start to stock up on area maps and brochures.

Other area historical houses include Buckman Tavern (1 Bedford Street), which dates from 1710 and was used as a militia headquarters; Hancock-Clark House (36 Hancock Street), which dates from 1727 and was a stop for Paul Revere; and Munroe Tavern (1332 Massachusetts Avenue), which dates from 1700 and now houses the Museum of the British Redcoats.

The Lexington Battle Green or Lexington Common, where the first shots of the Revolutionary War were fired, is located in the center of Lexington and features a fine statue of a Minute Man soldier complete with nearby American flag.

75. Minute Man National Historic Park

History buffs with cameras in hand to the front of the line.

Administered by the National Park Service, Minute Man National Historic Park is chock-full of Revolutionary-era history. The park commemorates the ground where the first Revolutionary War battles took place. The

Patriot's Day battle reenactment

park encompasses a large area—just shy of 1,000 acres—and runs through Lexington, Lincoln, and Concord. I've separated the visit into three geographic photo-op stops running east to west.

A good place to start is the Main Visitor Center, which offers "The Road to Revolution," a free multimedia show that gives a great intro to what happened that fateful day of April 19, 1775.

Patriot's Day, a Massachusetts (and Maine) state holiday, is observed every third Monday of April. American Revolution reenactments rule the day as does the re-created ride, on horseback, of course, of Paul Revere.

The Minute Man Visitor Center is at 250 North Great Road, Lincoln.
Call 978-369-6993 (park headquarters).
Hours are seasonal. Knowledgeable and friendly park service rangers are always on hand to answer questions as well as give guided tours.
www.nps.gov/mima

76. Battle Road Trail

Venturing westward throughout most of the park, you can bike or hike Battle Road Trail, a winding tree-lined perspective and walk in the woods once used by our colonial ancestors.

The 5-mile-long trail features a number of

Battle Road Trail mile marker

Hartwell Tavern

historical stops along the way. The entire trail is easily accessible by driving parallel east to west from Lexington to Concord along Massachusetts Route 2A, North Great Road and Lexington Road. Parking signs are quite prominent and parking areas let you break up the trip. Ranger-led 3½-hour guided seasonal tours depart from the Minute Man Visitor Center.

The first stop is the Paul Revere Capture Site, the place where everybody's favorite midnight rider was captured, and eventually released, by British soldiers. A monument marks the approximate spot.

At Hartwell Tavern on Route 2A in Lincoln, costumed rangers offer interactive tours and musket-firing demonstrations from May through November.

The Wayside Home of Authors (455 Lexington Road, Concord) offers local literary history—the house was once owned by writers Nathanial Hawthorne, the family of Louisa May Alcott, and Margaret Sidney. Guided seasonal tours cost $5.

77. Concord/North Bridge/Minute Man Statue

Continuing westward along Lexington Road, you'll eventually wind through the village of Concord proper, a perfect photo in which to capture small-town New England quaintness. Due east of the town center, the Concord Museum (Lexington Road and Cambridge Turnpike, 978-369-9609; www.concordmuseum.org) provides a worthy detour full of Revolutionary artifacts, literary riches once owned by Emerson and Thoreau, and a celebrated collection of Concord-style furniture.

Minute Man statue

Rounding out the Minute Man National Historic Park visit, just north of the town square is where you'll find two more photo ops to add to your colonial historical tour of the area: the North Bridge and the iconic Minute Man statue.

This replica bridge, built in 1956, is based on drawings from the original structure, which was constructed in the 1760s. The immediate area marks the spot of the Battle of Concord, considered the first Revolutionary War battle between the colonies and Great Britain.

Adjacent to the bridge you'll find the Minute Man statue created by Daniel Chester French. It's not as easy to photograph as you think, as you'll sometimes be joined by bus-loads of tourists during high season. In addition, nearby trees make morning shots a challenge, and the setting afternoon sun faces the statue from the rear. Here, you really want to capture the face of that intrepid Minute Man soldier but opt for a side silhouette. The statue, cast of American Civil War cannons, was dedicated at the battle's centennial commemoration in 1875. Inscribed in its base are the first four lines of Ralph Waldo Emerson's epic "Concord Hymn":

> By the rude bridge that arched the flood,
> Their flag to April's breeze unfurled,
> Here once the embattled farmers stood,
> And fired the shot heard round the world.

Now, if that doesn't sum up your trip to Boston and make the revolutionary hairs on the back of your neck stand on end, I don't know what will! And I can't think of a better sentiment with which to end this book.

The North Bridge Visitor Center is at 174 Liberty Street, Concord.
The site is open daily.

Suggested Guided Tours & Special Events

Boat Tours

The National Park Service leads ferry tours to the Boston Harbor Islands National Recreation Area's Georges and Spectacle Islands (about $12), departing from Long Wharf near the aquarium. Beach scenery, Boston Harbor, skyline views, historical structures, and local flora and fauna fill the frame. Call 617-223-8666 or visit www.bostonharborislands.org. Also visit www.nps.gov.

For maritime flair, Boston Harbor Cruises offers local harbor and whale-watch cruises and ferry excursions to Cape Cod and Provincetown. Call 617-227-4321 or 877-733-9425. Also visit www.bostonharborcruises.com. A helpful resource is *The Photographer's Guide to Cape Cod & the Islands* by Chris Linder.

Boston's Best Cruises offers whale-watch and Boston Harbor Islands cruises, local T Harbor Express commuter boat and water taxi service to Logan Airport, and ferry service to Salem. Call 617-222-6999 or visit www.harborexpress.com.

Charles Riverboat Company Tours offers Boston Harbor, sunset, and Charles River Basin cruises that start at $14. Call 617-621-3001 or visit www.charlesriverboat.com.

Bus Tours

CityView Trolleys offers hop-on/hop-off sightseeing bus tours of Boston, Cambridge, and Salem. An all-day pass for adults costs about $34 (save a few bucks by ordering the ticket online). Call 617-363-7899 or visit www.cityviewtrolleys.com.

Saint Patrick's Day

Saint Patrick's Day is a source of pride in the city—South Boston is indeed the place to be.

That said, the annual parade day is usually the Sunday before the actual holiday. Expect a very large crowd partaking of numerous libations (perhaps it's a good time to ditch the SLR and use the less expensive point-and-shoot for the day!).

Boston Marathon

The Boston Marathon, first run in 1897, is the premier race of its kind in the United States, if not the world. The runners number 20,000 strong. It's held every third Monday of April, also known as Patriot's Day, a legal holiday in Massachusetts. Visit www.bostonmarathon.org.

Boston Dragon Boat Festival

Held every mid-June on the Charles River in Cambridge (take the Red Line to Harvard Square stop), the Hong Kong Dragon Boat Festival celebrates this age-old Chinese sport in quite colorful style. Visit www.bostondragonboat.org.

Boston Harborfest

The colors to photographically explore are red, white, and blue. Boston Harborfest is the annual weeklong Fourth of July celebration. Costumed patriots, military drills and parades, and majestic tall ships take center frame. Visit www.bostonharborfest.com.

Saint Anthony's Feast

Somebody say amen! Saint Anthony's Feast, held annually during the last weekend of August in Boston's North End, adds throngs of revelers, colorful parades, and decorated streets to the shot. You are indeed in Little Italy, so the food is phenomenal. Visit www.stanthonysfeast.com.

Practical Boston Travel Info

When to Visit

Boston is busy year-round and each season brings with it a variety of things to do and unique photo ops. From a winter observatory view high above the city to Saint Paddy's Day pride, the Red Sox of summer to a whale watch in fall, a visit is recommended any time of year.

What to Bring

Besides your camera gear, casual clothes wear well in Boston. Comfortable sneakers or shoes are a must—heels on those cobblestone streets of Beacon Hill are not recommended. Summertime can be hot and humid, so shorts and T-shirts are fine. A Windbreaker comes in handy in spring and fall and even summertime sea cruises. And be prepared for Boston's version of Old Man Winter. A warm coat and gloves are in order.

Getting Around Town—Public Transportation

From Charlestown to the North End, Beacon Hill to the Back Bay, Boston is a great walking town. In addition, the extensive subway system, the T, as it's affectionately known by the locals, is fairly easy to navigate even for beginners.

Visit the Massachusetts Bay Transportation Authority, the MBTA, for maps, prices, fun facts, safety tips, and more at www.mbta.com.

Safety

Boston is one of the safest large cities in the world. That said, use your common sense. Travel with a friend. Don't flaunt your camera gear. Be aware of your surroundings any time of day. Don't photograph people who don't want their photo taken. And traveling with a seasoned tour guide for excursions off the beaten path is recommended.

Tourism Resources: Useful Telephone Numbers & Web Sites

Massachusetts Office of Travel and Tourism is the official statewide tourism resource. Call 800-227-MASS (800-227-6277) or visit www.massvacation.com.

The City of Boston official government Web site offers plenty of information for residents and tourists alike, including city history, things to do, getting around town, and culture and recreation. Visit www.cityofboston.gov.

Another fine citywide resource is the Greater Boston Convention and Visitors Bureau. Call 888-SEE-BOSTON (888-733-2678) or visit www.bostonusa.com.

Museums of Boston is a wonderful online resource that provides pertinent info on museums throughout the Boston metropolitan area. Visit www.museumsofboston.org.

If you'd like some words of wisdom to accompany your photos, the Boston History Collaborative offers online access to the Literary Trail of Greater Boston, a 20-mile-long journey of local literary heritage stops that highlight the region's rich history of writers, poets and authors. Visit www.bostonhistory collaborative.org/literarytrail.